creative
colored pencil
workshop

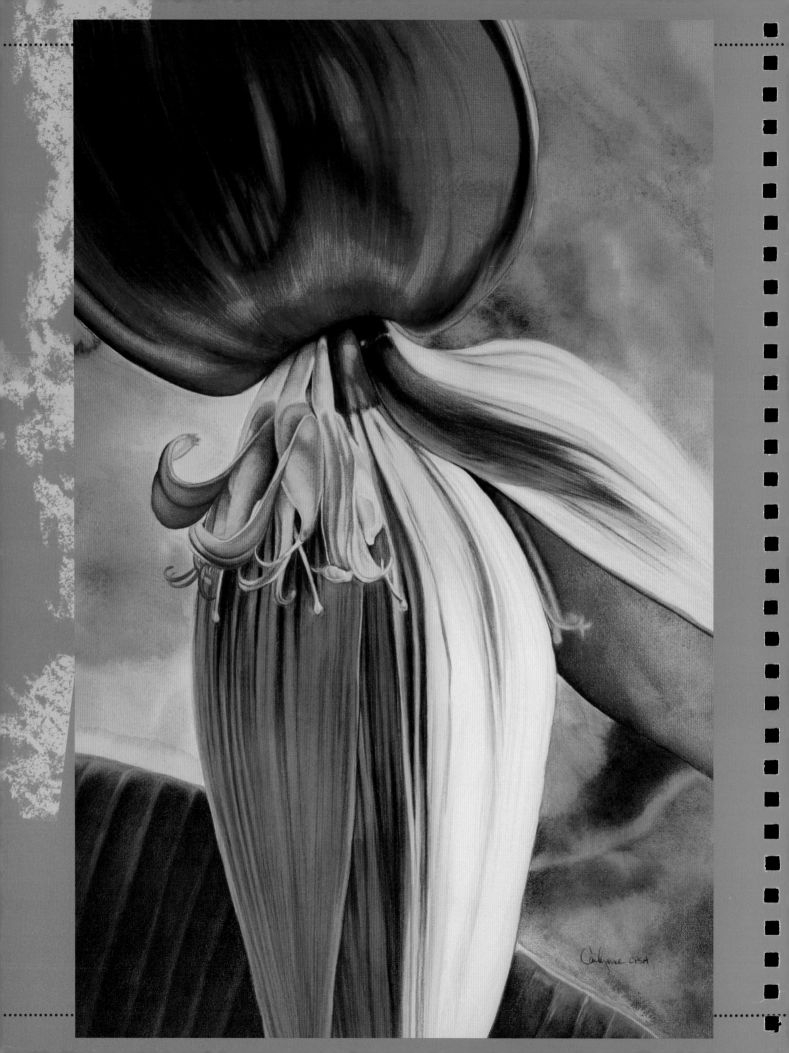

creative
colored pencil
workshop

26 Exercises for Combining Colored Pencil With Your Favorite Mediums

Carlynne Hershberger
and Kelli Money Huff

NORTH LIGHT BOOKS
CINCINNATI, OHIO
WWW.ARTISTSNETWORK.COM

about the authors

Carlynne Hershberger is a charter and signature member of the Colored Pencil Society of America and is past president of the Florida chapter. Her artwork has won numerous awards and has been recognized at the CPSA Annual International Exhibition, the Cornell Museum Points of Color and Autumn Artfest. Her work has been seen in *The Artist's Magazine*, *Pastel Journal*, *American Artist Drawing* and the North Light book *Colored Pencil Explorations*.

Kelli Money Huff has taught college courses in drawing, design, printmaking and painting. She is a national award winner and member of CPSA, a past vice-president of the Florida chapter, and a member of the Florida Watercolor Society, the National Watercolor Society and the American Watercolor Society. Her work has appeared in *The Artist's Magazine*.

The authors teach workshops and courses on a variety of mediums, including combining colored pencil and watercolor and making monotypes. Contact them at: hershbergerhuff@hotmail.com

Creative Colored Pencil Workshop. Copyright © 2007 by Carlynne Hershberger and Kelli Money Huff. Manufactured in China. All rights reserved. No part of this book may be reproduced in any form or by any electronic or mechanical means including information storage and retrieval systems without permission in writing from the publisher, except by a reviewer who may quote brief passages in a review. Published by North Light Books, an imprint of F+W Publications, Inc., 4700 East Galbraith Road, Cincinnati, Ohio, 45236. (800) 289-0963. First Edition.

fw
F+W PUBLICATIONS, INC.

Other fine North Light Books are available from your local bookstore, art supply store or direct from the publisher.

11 10 09 08 07 5 4 3 2 1

Distributed in Canada by Fraser Direct
100 Armstrong Avenue
Georgetown, ON, Canada L7G 5S4
Tel: (905) 877-4411

Distributed in the U.K. and Europe by David & Charles
Brunel House, Newton Abbot, Devon, TQ12 4PU, England
Tel: (+44) 1626 323200, Fax: (+44) 1626 323319
Email: postmaster@davidandcharles.co.uk

Distributed in Australia by Capricorn Link
P.O. Box 704, S. Windsor NSW, 2756 Australia
Tel: (02) 4577-3555

Library of Congress Cataloging in Publication Data

Hershberger, Carlynne
 Creative colored pencil workshop / Carlynne Hershberger and Kelli Money Huff.
 p. cm.
 Includes index.
 ISBN-13: 978-1-58180-818-6 (hardcover with wire-o binding : alk. paper)
 ISBN-10: 1-58180-818-6 (hardcover with wire-o binding : alk. paper)
 1. Colored pencil drawing–Technique. 2. Art–Technique. I. Huff, Kelli Money II. Title.
NC892.H47 2007
741.2'4-dc22
 2006029402

Edited by Amy Jeynes
Designed by Stanard Design Partners
Cover designed by Guy Kelly
Production coordinated by Matt Wagner

metric conversion chart

To convert	to	multiply by
Inches	Centimeters	2.54
Centimeters	Inches	0.4
Feet	Centimeters	30.5
Centimeters	Feet	0.03
Pounds	Kilograms	0.45
Kilograms	Pounds	2.2
Ounces	Grams	28.3
Grams	Ounces	0.035

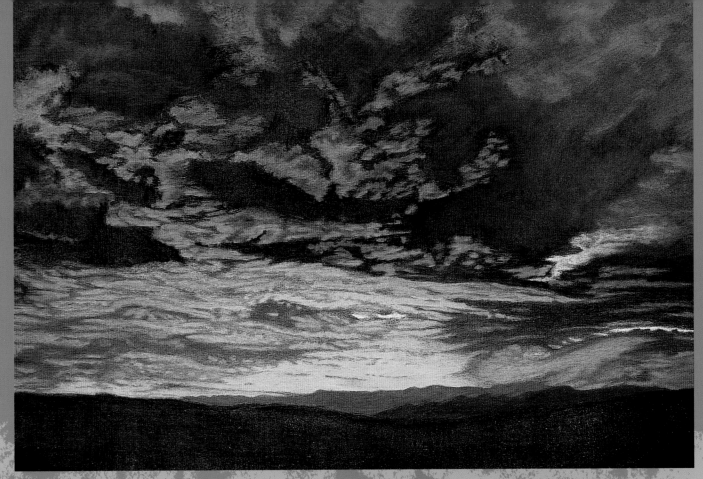

acknowledgments **dedications**

Jim's Sunset on the 5
Kelli Money Huff
Watercolor and colored pencil
9½" × 12½" (24cm × 32cm)
Collection of Shelley Money and James Webster

We would like to thank the following people who helped make this book a reality:

Orval Swander at Red Swan Paint and Art in Ocala, Florida. Thank you, Orval, for many things.

Our students, both past and present, who taught us to be teachers. We have learned as much from you as you have from us.

Vera Curnow for creating the Colored Pencil Society of America and helping colored pencil gain the respect it deserves.

All of our contributing artists for sharing their beautiful work with us.

Amy Jeynes for helping us make this book a reality, and Jamie Markle for believing we could be authors.

And, finally, all those other "immature" and "unfocused" artists out there who, like us, have trouble sticking to one medium and continue to experiment every day.

This book is dedicated to my grandmother Anna Dilia Fernandez, I know you're still with me. To my parents Josephine and Oscar, you always believe in me. To my very supportive husband Mark, you're always here for me. To my wonderful children Aaron, Sarah and Liz, together at last.

—*Carlynne Hershberger*

To my mother, Viola "Johnie" Money, who gave me her passion for art.

To my husband, Greg Huff, who believes everyone needs a passion.

To my daughter, Amber Huff, who truly is a work of art.

—*Kelli Money Huff*

table of contents

Carlynne CPSA

introduction

Meandering
Carlynne Hershberger
Collage with colored pencil
14½" × 9½" (37cm × 24cm)

Only in recent years has colored pencil come into its own as a bona fide art medium, due primarily to Vera Curnow, founder of the Colored Pencil Society of America (CPSA). While there are still some who look upon it with disdain, you only have to view an exhibition of work done in 100% colored pencil, such as the CPSA's Annual International Exhibition, to realize the phenomenal potential of this medium. The art done in colored pencil can be abstract or representational, loose or tightly detailed, soft and impressionistic or photorealistic. The quality is top notch, and colored-pencil art is accepted into the most prestigious shows the world has to offer. Some professional artists make colored pencil their primary medium, while others are adding it to other mediums—which is what we like to do, as you will see in this book.

Some might view us as a bit lazy, but in reality we are just in a hurry to get to the good stuff. That is why we like to combine colored pencil, which is a very slow medium, with other, faster mediums. Wet mediums are usually faster and better at achieving saturated color than colored pencil; however, pencil is unsurpassed in giving the artist control when it comes to details. Can we achieve these same details with a brush? Of course, but quite often it's more effective with the point of a pencil.

Carlynne is a colored-pencil artist with more than twenty years' experience with the medium; she also paints in oils. Kelli began her art life as a printmaker in college and picked up watercolor as a reaction to the "acrylic is the only medium and abstract is the only way to paint" atmosphere of the 1970s. When we began working together several years ago, we both started experimenting with more mediums, always gravitating back to colored pencil, but at the same time constantly learning new ways to combine it with other art mediums.

Like many artists, we have been teaching students of all ages for many years. We can't think of a better way to reach more of you than to put what we do into a book. We want to share with you our love of mixed media and experimentation. Between the two of us, we have worked with most mediums available to artists today. We are always combining various types of paint, pencils and pastels as well as making prints and then embellishing them with anything that sounds good at the time. For us, making art is a pleasure and a compulsion; we believe rules are to be learned and then broken.

This book is about combining colored pencil with various other mediums. Because there is so much to cover in this volume, there are many important skills that are not included. We encourage you to consult other books on basic drawing skills, the elements of design and the fundamentals of successful compositions.

We hope you will enjoy this book and that it will be helpful in your work. We also hope we will inspire you to do your own experimenting.

Carlynne Hershberger

Kelli Money Huff

basic skills for colored pencil

Colored pencil can be applied in a variety of ways: light tonal layers for a soft look, layered with heavy pressure to burnish, hatching and crosshatching for a linear effect or dissolved with mineral spirits for a truly painterly look. The manner in which you hold the pencil and the sharpness of the point can be varied to achieve different effects.

This chapter covers the properties of colored pencils and basic techniques for using them. Familiarize yourself with these, and you'll be on your way to choosing surfaces, combining colored pencils expertly with other mediums and developing your personal style.

The Market
Carlynne Hershberger
Colored pencil on multimedia board
17½" × 10" (44cm × 25cm)

choosing colored pencils

If you're new to colored pencils or if you just want to know more about them, here is all the information you need.

what are colored pencils?

Colored pencils are made of a core consisting of pigment combined with either a wax or oil binder, encased in wood. The colored pencils we used as children bear only a slight resemblance to the ones professional artists use. Professional pencils are much more blendable and lightfast, and their higher pigment load results in more saturated color.

tip

It's good to know how your art supplies are made, but people enjoy this to different degrees. Kelli says, "I like to know everything, right down to the name of the person who put the pigment in the vat." Carlynne says, "I don't care where it came from—just let me paint!" Everyone is different.

It's OK if you don't want to delve too deeply into the ingredients of your materials, but it pays to know some basic information so that that your paintings won't crack, peel or slide off the paper. Throughout this book, we'll give you the essential feedback in sidebars such as the one above, "What Are Colored Pencils?"

properties of colored pencils

Hardness. Colored pencil brands vary in hardness. See the chart on page 13 for information about several major brands. Some brands are creamy and blend very well but build up a layer of wax quickly, while others are harder and less blendable but take more layers due to less wax build-up. Wax-based pencils give good coverage quickly but can be affected by wax bloom, a milky film that rises to the top of the pencil layers, especially with dark colors. You can polish wax bloom away with a soft cloth, then spray final fixative on the painting to keep wax bloom from returning. (Test the spray first to see how it changes your colors.) Oil-based pencils do not have the problem of wax bloom.

Lightfastness. Look for lightfast brands so that the art you work so hard on will last for the ages. Quality pencils meet lightfastness standards set by the ASTM. You can find lightfastness data in the manufacturer's literature, on the pencil packaging or sometimes even printed on the pencil itself. Manufacturers are also improving the lightfastness of some colors that did not meet ASTM standards in the past. The Colored Pencil Society of America (CPSA) worked for years to make this happen.

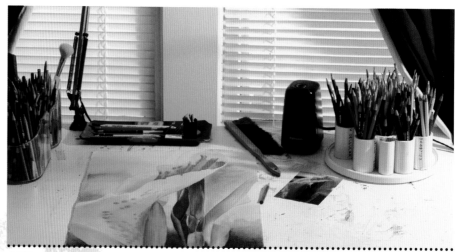

A Workspace
Carlynne's workspace. Like the pencil holder? See page 15 for instructions on how to make it.

characteristics of major brands

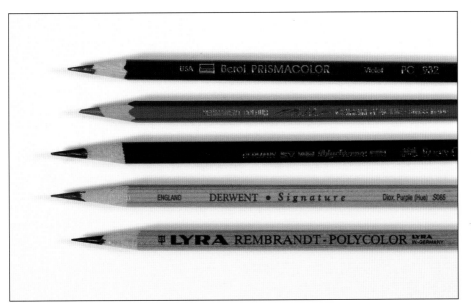

This chart covers five of the most readily available quality brands of colored pencils. There are other brands out there; buy a few of several brands and experiment to discover your personal preferences.

Don't hesitate to mix and match pencils of different brands in the same painting. Both of us usually mix brands, sometimes just for choice of colors and other times for certain effects.

Some Major Colored Pencil Brands

Shown here, from top to bottom, are Sanford Prismacolor, Caran d'Ache Pablo, Faber-Castell Polychromos, Derwent Signature and Lyra Rembrandt Polycolor brands.

Characteristics	Sanford Prismacolor	Caran D'Ache Pablo	Faber-Castell Polychromos	Derwent Signature	Lyra Rembrandt Polycolor
Binder	Wax	Oil	Oil	Wax	Oil
Shape and lead size	Round 3.8mm	Hexagonal 3.7mm	Round 3.8mm	Round 4mm	Round 3.8mm
Number of colors available	120	120	120	60	78
Lead hardness	Very soft and creamy	Soft	Medium soft	Hard	Soft
Techniques					
Tonal layering	Good, but needs frequent sharpening. Keep pressure light; otherwise too much wax builds up	Very good; nice, smooth application	Excellent	Excellent; holds a point well	Very good
Burnishing	Excellent creamy consistency gives nice painterly look	Good	Good	Drags a bit with heavy application pressure	Nice smooth application
Dissolving with solvent	Excellent	Good	Good	Dissolves well but needs a lot of pigment applied first	Good

Sharpeners and erasers are probably the most necessary tools for the colored-pencil artist, but there are others that will be very useful.

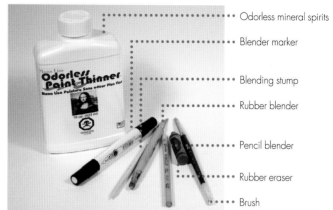

Odorless mineral spirits
Blender marker
Blending stump
Rubber blender
Pencil blender
Rubber eraser
Brush

Blending Materials

Lyra and Prismacolor both make a colorless blender that looks just like a colored pencil but has no colored pigment, just binder. These are useful for burnishing (see page 17) or blending colored pencil. You can use either brand with all pencils. Odorless mineral spirits are also good for blending colored pencil; when brushed on, they dissolve applied colored pencil to an almost paint-like consistency.

The rubber eraser is a great blending tool. It looks like a crayon but is actually a vinyl eraser sold as a party favor at party shops. Thanks to Melissa Miller Nece for sharing this idea with us. She uses it to blend colored pencil, and it's a great tool for oil pastel as well.

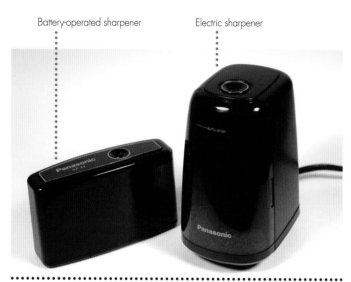

Battery-operated sharpener
Electric sharpener

Sharpeners

A very sharp point is often important in colored pencil work, so a good electric or battery-powered sharpener is a must. Hand-held sharpeners won't give you a really sharp point. We use an electric model in our studios and a battery-powered one for carrying to classes. You will find that most models tell you not to use them with wax-based pencils, but we do, and we don't have problems.

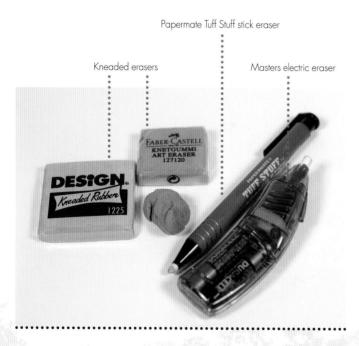

Papermate Tuff Stuff stick eraser
Kneaded erasers
Masters electric eraser

Erasers

The most useful type of eraser is an electric one. Electric erasers can usually remove colored pencil back to white paper (though some colors do stain and will never be completely removed).

We know of three different brands of electric eraser that range in price from $8.50 to over $50. The most expensive, Sakura, is also the best, but the others, Masters and Helix, still do the job. We've owned all three and like the Sakura the best and the Masters second. The eraser points are replaceable and sold separately. The Masters and Sakura eraser points are interchangeable.

Kneaded erasers and white vinyl erasers are also useful for blending, lifting and removing smudges.

An erasing shield, designed for draftsmen, works with any type of eraser to help you erase in tight spaces.

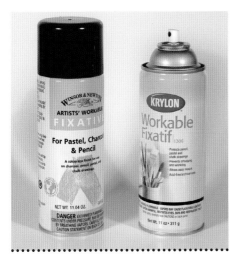

Spray Fixative

There are two kinds of fixative, both of which you'll find handy:

Workable fixative helps prevent graphite and colored pencil from smudging while allowing you to continue applying color on top of it.

Final fixative is a final protective coat for the finished art. Final fixative will also keep wax bloom away. That's the milky white stuff that forms on the top of heavy layers of darker colors. To remove wax bloom, wipe it with a soft, clean cloth, then spray the work with final fixative. The fixative will keep wax bloom from coming back. Oil-based pencils do not have the problem of wax bloom.

Spray fixative will cause some change in color, so test on a sample swatch first.

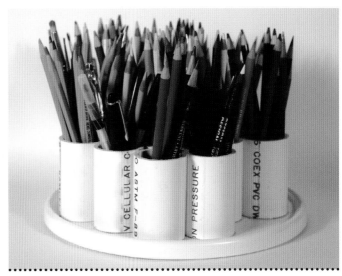

Pencil Holder

You can purchase all manner of holders and storage systems for colored pencils. One of our students, Diane Laws, came up with the idea to make her own spinning pencil holder by gluing lengths of PVC pipe to a plastic lazy Susan. Diane used PVC pipe in several sizes, including 1-inch (25mm) and 1½-inch (38mm). You can use any strong glue that works for plastic, such as silicone or E6000.

Drafting brush Soft mop brush

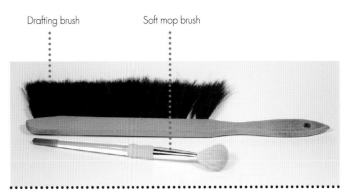

Soft Brushes

You will need brushes to remove crumbs and keep your paper clean. Brushing away crumbs of colored pencil with your hand could smudge your work. Drafting brushes are made for this purpose, but you can also use inexpensive cosmetic brushes designed to apply face powder. The small size of the cosmetic brush makes it particularly useful for traveling. Any soft brush will work.

application

• Most techniques require a sharp point. The sharpness of the pencil has a lot to do with the look of the stroke and, ultimately, the quality of your drawing.

• It is usually best to start a painting with a slow layering process. Try to make the paper tooth last through many layers. Light layers are easy to erase or to change with the addition of more layers. If you burnish in the early stages, it will take a lot of erasing to change direction.

• Instead of always using solvent to blend, try a bristle brush with the bristles cut very short. Rub with gusto over a heavy layer of color.

color

• Colored pencils are semitransparent and can be layered over each other or another medium. Lighter colors are more transparent; darker colors have more covering power.

• To make black, layer several dark colors over each other. Black pencil is a very dead color. You can get good darks using colors such as Indigo, Dark Indigo, Dark Green, Tuscan Red and Dark Umber—use two, three or all of these as needed. If you layer Black pencil with other colors, it will not look as dead as it would if you used Black alone.

workspace and tools

• The texture of your drawing board can become transferred to your drawing. To prevent this, cushion the drawing with additional paper or cardboard underneath.

• Always work with a good light source. Lack of light leads to eyestrain and unpredictable color. In a perfect world, it would be nice to have natural, color-correct full spectrum lighting throughout your studio. We have color-correct bulbs in some of our work lamps, but we also realize that once a piece leaves the studio, we have no control over the light under which it will be displayed. So we don't consider color-correct lighting a necessity in every fixture in our studios.

• To make a value finder, use a hole punch to put one hole in the middle of each of two unlined index cards. Place one hole over the reference photo and the other over the same area in your drawing. Compare values and color. Thanks to artist Ann Kullberg for this idea.

keeping your paper clean

• Your colors can easily be contaminated by residue from the oils on your skin, crumbs of pigment, dust and erasures. A brush will remove crumbs, and a kneaded eraser will get rid of smudges. Protect your painting with a *bridge*, a piece of paper on which to rest your hand. The glossy side of a photo

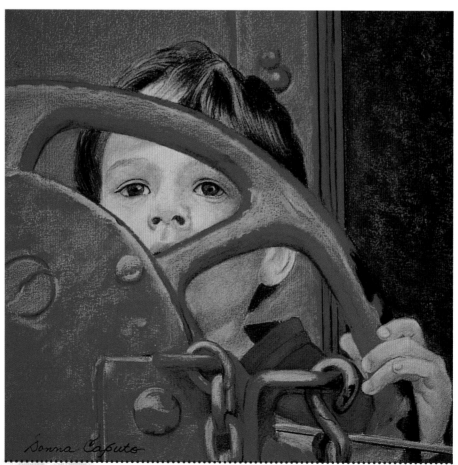

Donna Caputo used odorless mineral spirits on this attention-getting colored-pencil piece. She also used the side of her pencil lead at times to get the textures of rust and old wood.

Behind the Wheel
Donna Caputo
Colored pencil on
Crescent #300 cold-pressed illustration board
8" × 8" (20cm × 20cm)

works well as a bridge; its smooth finish doesn't smudge or lift the pigment.

• After sharpening a pencil, wipe it on a soft cloth or brush to remove crumbs from the pencil point that might make marks on your drawing. One of our students taped a small cosmetic brush to the top of her sharpener for brushing the point after sharpening. Thank you, Carole!

ideas for experimentation

• Save drawing paper scraps to test color mixing or techniques.

• Create a notebook to test a sample of all your colors. Label each by color name and brand. Keep this as a permanent reference and add samples of new colors as you acquire them.

guide to colored pencil strokes

If you're new to colored pencils, consult this illustrated guide for help with the basic strokes.

For tonal layering, keep the point sharp, use light pressure and change the direction of the strokes with each layer. Your goal is a smooth area of color without the look of pencil strokes.

To scumble, use continuously overlapping circles. Do not do the circles in rows; overlap them in a random pattern. This technique gives you a dark value faster than tonal layering, but with more texture.

Vertical line means just that—all strokes are vertical. Lift the pencil point at the end of each stroke. Vary the stroke lengths so that you don't have dark bands where the strokes overlap. Leave a little bit of space between the strokes for adding more color.

To crosshatch, begin with pencil strokes placed close together and parallel to each other. Then turn the paper and add another layer of strokes at a different angle to darken the value.

To stipple, use the point of the pencil to make small dots. Change the value by varying the size and/or spacing of the dots.

Burnishing means layering with heavy pressure. Heavy pressure with one color looks like this. Burnishing with white makes a lighter tint of the color underneath. Burnishing with a colorless blender deepens the color.

tonal layering

Tonal layering is the method of applying colored pencil with a sharp point in multiple light layers to build color. The goal is a smooth area of color without visible pencil strokes. Mix colors by layering them over one another to achieve just the right value and color.

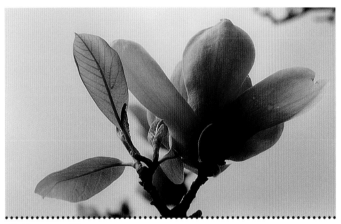

Reference Photo

materials

Colored Pencils
Polychromos: Apple Green, Burnt Ochre, Dark Green, Light Flesh, Light Purple, Medium Flesh, Pink Madder Lake, Rose Carmine, Sap Green, Wine Red
Prismacolor: Black Cherry, Dark Umber, Chartreuse

Surface
Canson Classic Cream drawing paper, 80-lb. (170gsm)

Other
Graphite pencil

tip

Always work under plenty of light. If the light is too dim, you might overcompensate by putting the color down with too much pressure. This can cause problems with subsequent layers, such as too much wax buildup too soon; uneven, grainy appearance; or difficulty in removing color when needed.

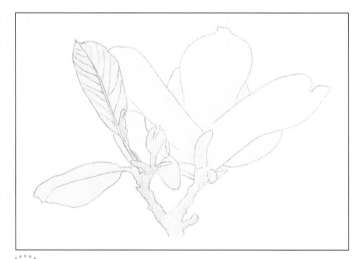

 Draw, Then Apply the First Layers

Lightly draw the magnolia blossom with a graphite pencil.

Begin layering Light Flesh on all the petals with a very sharp point and light pressure. Use fine strokes that are close together for smooth, even coverage. The color is barely there, but that's OK.

Put down a layer of Chartreuse on the leaves. Lightly layer Burnt Ochre on the tree branch.

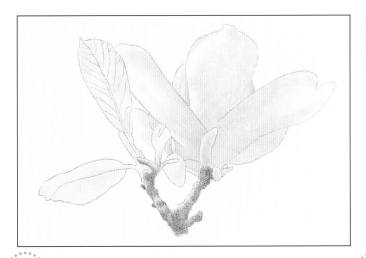

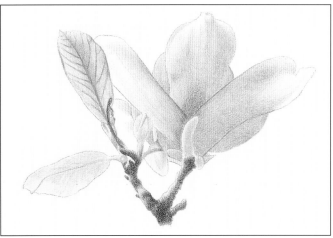

2 Add More Color and Begin Modeling

Now put a sharp point on the Medium Flesh pencil and layer the petals once again with light pressure—except this time, apply color only to the medium and dark areas of the petals, avoiding the lightest areas. Put the strokes down in a different direction than you used in step 1. Begin modeling shadow areas by adding some Medium Flesh to the leaves and a very light layer of Dark Umber to the darkest parts of the branch.

3 Deepen the Colors

Build up the color on the petals with Rose Carmine and Pink Madder Lake. Follow the contours of the petals with your pencil strokes to indicate vein lines. With Apple Green, begin darkening the veins on the leaves. Use Apple Green and Sap Green to darken the leaves along the outside edges and alongside the center vein. On the branch, add a layer of Black Cherry on top of the Dark Umber. Remember, this is tonal layering, so sharpen that pencil!

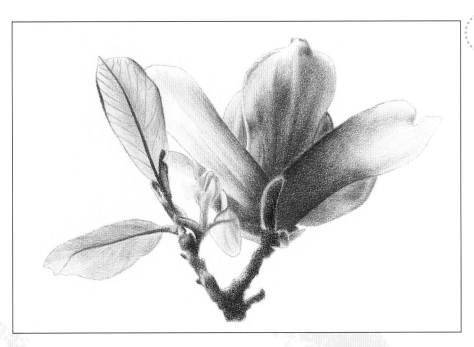

4 Add the Dark Values

Layer Wine Red over the medium-value and dark areas of the petals. Do a second layer over just the darkest shadow areas. With very light pressure, bring some lines up the length of the petals for texture. (Use too much pressure and you could end up with a striped flower).

If the overall texture of the petal isn't smooth enough, sharpen the Wine Red pencil and change the direction of the strokes to fill in the small specks of white paper that show through. Use Dark Green on the veins and edges of the leaves.

Layer Black Cherry on all the darkest areas of the petals, leaves and branch. Touch up, blend and smooth the textures as needed with additional light layers of the lighter-value pencils used previously.

burnishing

Burnishing means applying colored pencil (or colorless blender) on top of existing colored pencil layers with heavy pressure for a smooth, lustrous finish.

In the previous exercise, Tonal Layering, you applied light colors first. This time, you will work in reverse. There really isn't a hard-and-fast rule about working dark over light or light over dark.

materials list

Colored Pencils
Polychromos: Burnt Ochre, Light Flesh, Rose Carmine
Prismacolor: Beige, Black Cherry, Chartreuse, Dark Umber, French Grey 50%, Olive Green, Pink, Raspberry, Tuscan Red, White

Surface
Canson Classic Cream drawing paper, 80-lb. (170gsm)

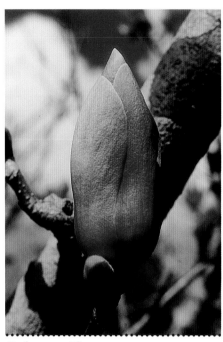

Reference Photo

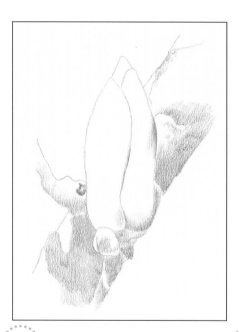

1 Draw, Then Block in Shadows

Lightly draw the subject on your paper. Block in all shadow areas on the flower bud and branch with Black Cherry. On the flower, be sure to feather out the strokes and keep the edges soft. You want these areas to transition smoothly into the lighter colors later.

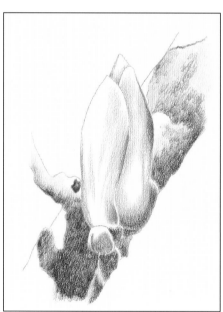

2 Add Color to the Branches, Buds and Foreground

Layer Raspberry on the bud, going on top of the Black Cherry and extending beyond it but avoiding the lightest areas. Add Burnt Ochre to the branch except for its lightest areas. Scumble Dark Umber on the branch shadows. Add a touch of Olive Green in the foreground.

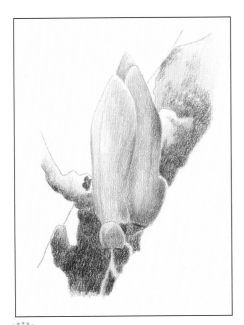

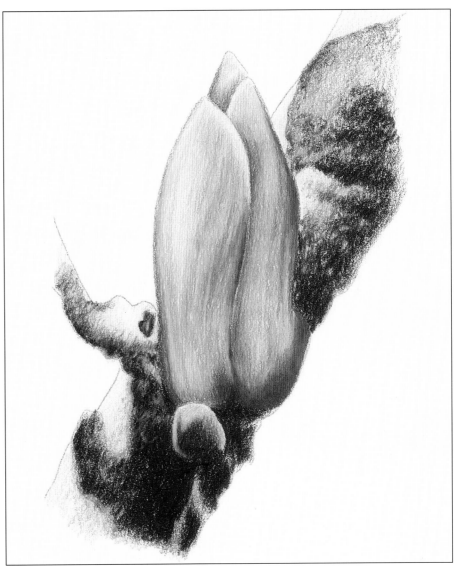

3 Layer Color Onto the Flower

Now add layers of Rose Carmine and Pink over the whole flower. As in step 2, you don't have to be especially careful about the sharp point and light pressure, but you don't want to be sloppy either. Just maintain a nice, even, medium pressure throughout.

Start using some vertical strokes to indicate the veins in the petals. Follow along with the curve and do some directional strokes to give the petals a little texture.

Add a layer of Chartreuse to the green area in the foreground.

4 Finish

Here you'll introduce a couple of new colors. Layer Beige on all the open spaces left on the branch. Add some French Grey 50% in the same areas for texture. Use Light Flesh to fill in any light areas left on the flower bud.

Now here comes the scary part: Pick up a White pencil (don't put a sharp point on it) and, with heavy pressure, blend and smooth all of your previous layers. Did you notice the color change? Burnishing with white can create quite a dramatic change with some colors. Of course, when you add white to a color, you're going to make a lighter tint of that color, so you might have to go back into it with another layer of darker color.

Add some Tuscan Red to the shadows and to the bark on the branch. Finally, to intensify the colors and give them a last burnish, add more of the pinks and reds to the flower and more Dark Umber to the branch. On the tree branch, use a scumbling stroke with lots of pressure. On the flower, use strokes that follow the contour of the petals.

leaves in different strokes

In this exercise, you'll draw the leaves of a plant using several different strokes. It's a great way to compare the different effects that can be achieved with colored pencil. When you're familiar with the various strokes, experiment with different ways of combining them.

Reference Photo

materials

Colored Pencils
Prismacolor: Cream, Crimson Lake, Crimson Red, Dark Green, Deco Yellow, Grass Green, Limepeel, Tuscan Red, White
Pablo: Naples Yellow
Polychromos: Sap Green

Surface
Canson Classic Cream drawing paper, 80-lb. (170gsm)

Other
Graphite pencil

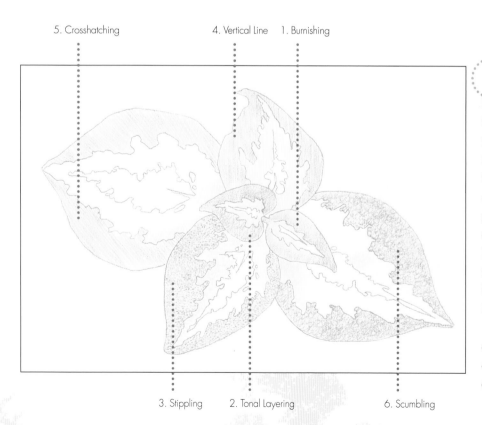

5. Crosshatching 4. Vertical Line 1. Burnishing

3. Stippling 2. Tonal Layering 6. Scumbling

1 Do the First Layers

Draw the leaves with a graphite pencil. Using the type of stroke indicated for each leaf, put in the first layer with Deco Yellow. Since this is such a transparent color, be careful to keep it away from the graphite lines—the graphite can dirty the yellow. With this layer you're not going to see much difference between the different strokes. That's OK. Keep the pressure light even though it's tempting to really grind it in so you can see it better. Leaves 1 and 2 will have the same first layer: a sharp point and light pressure.

Put some Deco Yellow on the lightest parts of the green sections. Next, use Limepeel to color all green areas of the leaves, using the appropriate strokes for each leaf.

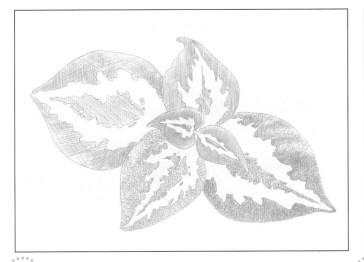

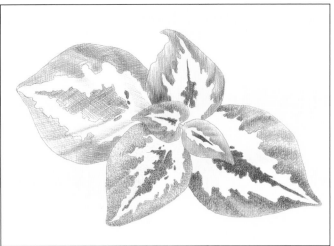

2 Add Red and Deepen the Greens

Use Crimson Red and Crimson Lake to fill in the centers of the leaves, again using the appropriate strokes for each leaf. Add a second layer of green using Sap Green. For tonal layering (leaf 2) and crosshatching (leaf 5), remember to change the direction of the strokes for each layer. Burnish leaf 1 with more pressure than leaf 2.

3 Build the Colors

Layer Grass Green and Crimson Lake in the areas shown using the appropriate strokes for each leaf.

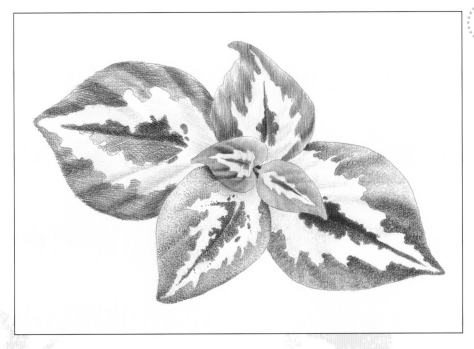

4 Finish

Use Dark Green to deepen the green areas of all the leaves. On leaf 1, use Cream and White to burnish and smooth the previous layers. With Naples Yellow, bring more color into the centers of all the leaves. Add depth to the drawing by adding cast shadows from the top leaves. You can do this by adding Limepeel and Naples Yellow to the stippled leaf just under the edge of the leaf above it. Deepen the red of the leaves by adding a layer of Tuscan Red. Finish the edges of leaves with Dark Green.

Study the white areas of the leaves. Most of them are not really white; you'll see more yellow and green. Use Limepeel, Deco Yellow and Naples Yellow to fill in the color in these areas.

using colored pencil with solvent

When solvent is used with colored pencil, the pigment looks and acts like paint. You can push the color around and blend it smoothly. You can add more color on top and still do some erasing. It's a completely different way of working with colored pencil than what artists have traditionally done.

Be sure to use odorless mineral spirits in a well-ventilated space. Just because the product is odorless doesn't mean there aren't toxic fumes.

materials

Colored Pencils
Prismacolor: Beige, Black Cherry, Burnt Ochre, Canary Yellow, Chartreuse, Clay Rose, Dark Brown, Dark Green, Dark Umber, Goldenrod, Greyed Lavender, Limepeel, Sepia, Sienna Brown, Terra Cotta, Yellow Ochre
Polychromos: Cinnamon

Brushes
Bristle brush such as a scrubber or hog bristle bright

Surface
Canson Mi-Teintes paper, Cream

Other
Odorless mineral spirits, paper towels, graphite pencil

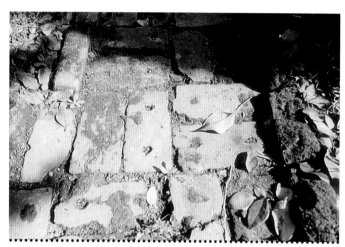

Reference Photo

1 The First Layer

Lightly draw the subject on your paper. Layer Beige over all areas except the leaves. Coat everything, including the spaces between the bricks. Don't worry about the point being sharp; you just want to get enough color down so that you have something to dissolve with the mineral spirits.

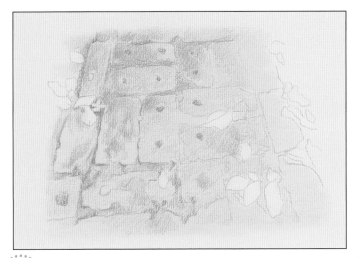

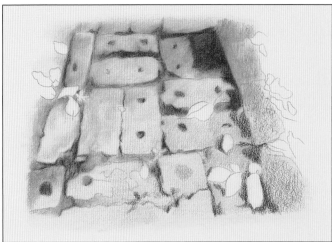

2 Dissolve the Color

Dip a stiff bristle brush in mineral spirits, then dab it on a paper towel to remove excess spirits. Use the brush to dissolve the Beige pencil you applied in step 1. With practice, you'll get the feel of how wet the brush should be.

When the paper is dry, begin adding more colors to the bricks. Add Greyed Lavender, Clay Rose, Goldenrod, Cinnamon, Burnt Ochre and Terra Cotta. The bricks have a variety of mottled tones, so you needn't be precise; just hold all of those pencils in one hand, then grab different colors at random.

3 Layer More Color, Then Dissolve Again

Using the side of the colored pencil lead, continue to layer the colors you used in step 2. To define the edges of the bricks, add some Dark Brown and Dark Umber. When you have some of each of the colors on the paper, it's time to dissolve the pigment again. Use the bristle brush and mineral spirits as you did in step 2.

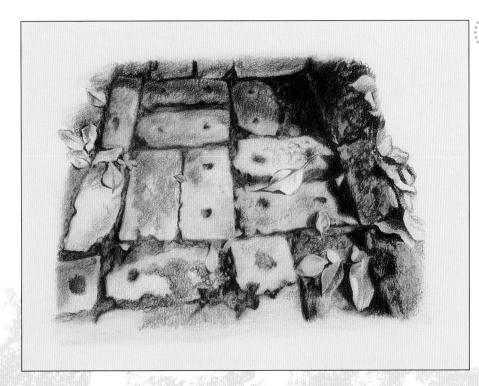

4 Finish

By now, all the bricks should have a layer of smooth, dissolved color on them. You can keep darkening shadow areas with more color and redissolve them, but since these are bricks, leave the last layer undissolved for more texture.

Add a bit of green moss on the bricks with Limepeel. Also add a touch of Chartreuse to the same area for brightness. Deepen the shadows with Black Cherry and Dark Umber. Try using the side of the lead to put these colors down; the layers underneath will peek through the broken color for more texture.

Last, for the leaves, layer Canary Yellow, Yellow Ochre, Burnt Ochre, Sienna Brown and Limepeel. Use Dark Green to deepen the color on the largest leaf in the lower right corner.

blending color

The reference photo for this exercise was taken at the fort at Castillo de San Marcos in St. Augustine, Florida. The fort is built from coquina, a kind of limestone formed over thousands of years from coquina clamshells. Colored pencil seems to perfectly describe the textures in the bricks, and Prismacolors are ideal for this painting because of their softness. They smudge and blend beautifully.

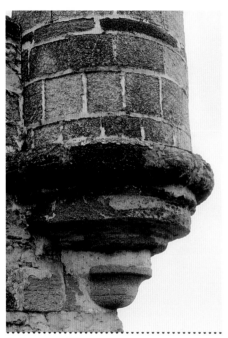

Reference Photo

materials

Colored Pencils
Prismacolor: Beige, Burnt Ochre, Clay Rose, Dark Brown, Dark Umber, French Grey (all percentages), Light Umber, Sand, Sepia, Sienna Brown, Warm Grey 50%, White
Pablo: Bistre, Ivory Black

Surface
Canson Classic Cream drawing paper, 80-lb. (170gsm)

Other
Vinyl eraser, Prismacolor clear blender marker, Prismacolor colorless blender pencil

1 Draw, Then Apply the First Layer
Lightly draw the subject on your paper. Apply Clay Rose and Sand, using the side of the lead. Using the same technique, apply French Grey 30% and Light Umber to the darker areas.

2 Start to Blend
Use the corner of a vinyl eraser to smudge and blend all the colors you applied in step 1. Start to deepen the darkest value areas with Bistre pencil applied loosely with the side of the lead. Smudge these darker areas with the eraser.

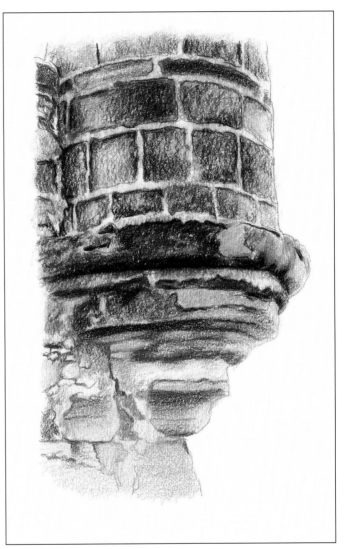

3 Redefine and Blend

With all the smudging, you might lose some of the outlines or edges. Use one of the brown pencils to redefine the lines.

Grab a handful of the light and middle-value colors, such as Beige, Clay Rose, Burnt Ochre, Sienna Brown and all the grays, and start applying these colors randomly. Some areas are lighter than others, so watch where you place the values.

Go over all your colors with a colorless blender pencil and a scumbling stroke. Don't get too heavy with the pressure, or the surface may get slick, making the next layers of pencil slide instead of grabbing the surface. If the color looks a little darker but you can still see some paper texture, you're doing great.

Notice the mortar between the blocks. Use the blender pencil to drag color from the blocks right over the mortar. That's all you'll have to do to color them. Make some areas lighter and some darker.

4 Use the Blender Marker

Apply Ivory Black and Sepia layers. Where you see lighter values, use a very light pressure with the side of the pencil lead. The idea is to skim across the surface for broken color. For darker areas, use heavier pressure, and where it's very dark, use the clear blender marker to dissolve the pigment and make it more solid.

Continue to add light and dark colors as desired. If an area needs to be smoother, you can go back to the blender pencil or use the broader end of the blender marker on it. Try using the fine-tip end of the marker to stipple some dark spots into the rough-textured areas of the blocks.

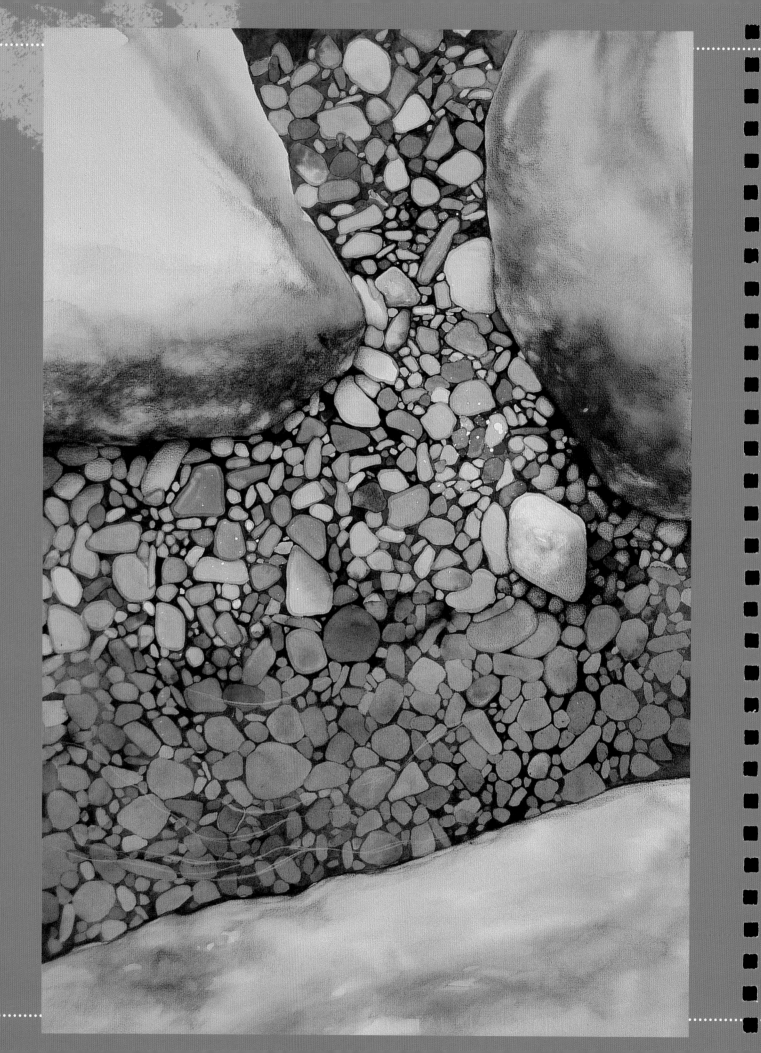

basic skills for other mediums

We consider ourselves very fortunate to be able to do what we do. Combining colored pencil with other mediums is exciting. The point of a pencil gives artists such control for details, yet colored pencil can also be used to create washes of color. The possibilities become truly infinite when we look at the array of mediums out there (with new ones still being invented) and add them to colored pencil.

If you hang around our studios, you will hear a lot of "Oooh, I'll have to try that!" Sometimes we actually have trouble sleeping at night due to the thrill we get from thinking about and planning new experiments with our art supplies. Do we have a favorite medium to combine with colored pencil? Yes: whatever we're currently using.

River Rock
Carlynne Hershberger
Watercolor and colored pencil
22" × 15" (56cm × 38cm)

watercolor

The flow and luminosity of watercolor paint thrills artists like no other medium. Thick paints and dry mediums stay where you put them; watercolor moves and changes on the paper and has a life of its own. Combining watercolor and colored pencils gives you the best of both worlds: the speed and serendipity of watercolor and the control of the pencil point.

Tubes of Watercolor

what is watercolor?

Most watercolor paint contains pigment, a binder (usually gum arabic) and glycerin. Professional-grade watercolor usually contains more pigment and less binder than student-grade. Student grades also substitute less expensive pigments for some of the more costly ones.

Watercolor comes in tubes and pans (also known as cakes). Tubes are the easiest to find. Be very careful when choosing pan colors to get professional-quality paints. They are not always labeled as such.

what you need

Buy watercolors in small tubes until you know what you like; then buy the larger tubes, which are a better value. If you are a beginner, practice color mixing and brush techniques with student-grade paints, then move up to artist quality as each tube needs replacing.

A good beginning is to purchase a warm and a cool version of each of the primary colors: red, blue and yellow. With these, you can mix all of the other colors.

Start with:

Warm Pyrrole Red Arylide Yellow Cobalt Blue

Cool Permanent Rose Hansa Yellow Lemon Phthalo Blue

If you like, you can increase your options by adding:

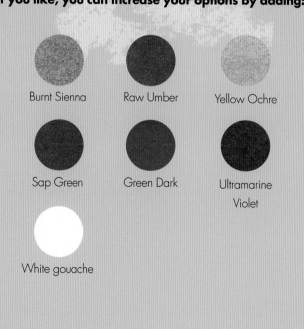

Burnt Sienna Raw Umber Yellow Ochre

Sap Green Green Dark Ultramarine Violet

White gouache

properties of watercolor

Lightfastness: The ability of a pigment to resist fading. Use lightfast colors so that your art will last.

Staining/Nonstaining: The tendency of a pigment to leave a stain on the paper when you lift off color. Almost every color stains to some degree.

Granulation: The tendency of some pigments to settle into the paper's nooks and crannies, producing a grainy look. Many earth tones are granulating colors.

Transparency/Opacity: The degree to which a pigment blocks light. Part of watercolor's beauty comes from the luminosity created by layered, transparent colors. This does not mean you should avoid opaque and semiopaque colors—just learn to use them to their best advantage.

tip

Color properties make a big difference to the outcome of your art. Sources of information include:

The manufacturer's brochure. Some, such as that put out by Da Vinci, contain very complete information. Be aware that color names mean nothing; the pigment listed on the label is what determines the paint's properties.

The Wilcox Guide to the Best Watercolor Paints (School of Color Publications, 2000). This is a great reference for paint properties. Michael Wilcox has been instrumental in getting manufacturers to improve product labeling and lightfastness.

Your own tests. If you aren't sure how a color will behave, test it. Keep a notebook in which you try various colors and techniques. Label each page so you don't forget what it is. Save the mistakes as well as the successes.

Transparency
All three of these watercolor swatches have pencil lines under them. This Carmine swatch is the most transparent of the three: You can see right through it to the pencil lines beneath.

Granulation
Ultramarine Blue is one of the granulating pigments, those that tend to settle in the paper texture rather than soaking into the fibers. Granulating pigments dry with a grainy appearance that's useful for textured subjects.

Staining
Phthalo Green is a pigment with high staining power. You can try to lift it out with a wet brush, as shown here, but it won't lift out completely. Test your paints so you know how much of a staining tendency they have.

tip

Tips for Working With Watercolor

• When mixing colors, strive to avoid "mud." Mud is not gray; it is when you've lost the transparency by mixing the wrong colors. Transparent colors mix better than opaque ones, and the fewer colors you mix, the less likely you are to get mud.

• To keep a painting luminous, plan with care to use fewer strokes and fewer layers. The exception to this is glazing; you can glaze many thin layers without losing the light.

• When in doubt, start a painting with the lightest values and end with the darkest. When you paint dark to light, darker paints might redissolve and contaminate lighter ones. If you paint light to dark and the lighter paint redissolves, it will not show.

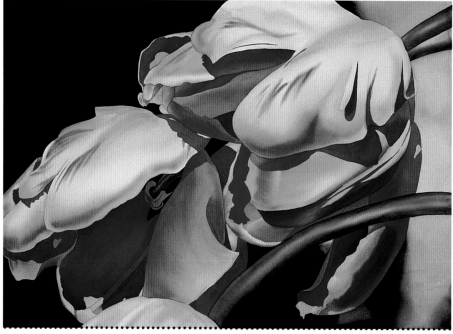

Birgit O'Connor floats watercolor on wet paper and then tilts the paper to help the color move in a natural way.

Dancing Tulips
Birgit O'Connor
Watercolor
30" × 40" (76cm × 102cm)

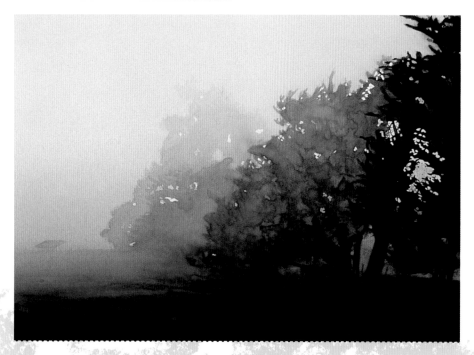

Catherine Anderson applies pale washes of watercolor in many layers to get a wonderful atmospheric effect.

Rainy Days
Catherine Anderson
Watercolor
22" × 30" (56cm × 76cm)

watercolor paper

We use watercolor paper probably more than any other surface. Your choice of watercolor paper has a tremendous effect on the finished art. Here, we'll tell you about surface texture, sizing, weight and other characteristics to consider when choosing a paper for a specific project.

what is watercolor paper?

The best watercolor paper for quality artwork is "100% rag" or "100% cotton," which means the paper is made made from cotton fibers with no wood pulp. Wood pulp is undesirable because it is high in acid and will discolor and deteriorate.

Watercolor paper also contains sizing, a gluelike additive that slows the absorption of water into the paper. Sizing makes smooth washes possible. Different manufacturers use different types and amounts of sizing; this is quite often what causes artists to have favorites among the various papers available.

What You Need

Watercolor paper can be purchased in pads, in blocks or by the sheet.

Pads: An inexpensive spiral-bound pad made for water-based mediums (check the label) is handy for practicing techniques and testing colors.

Blocks: A block is like a pad, but bound on four sides and mounted on a heavy cardboard backer. Blocks are designed for painting in the field; take one with you and paint anywhere.

Sheets: This is the least expensive way to buy quality paper. Watercolor papers come in a standard size of 22" × 30" (56cm × 76cm). There are other sizes, but this is the most readily available. A full sheet can be cut into halves and quarters for smaller paintings.

Two papers sold by the sheet that we particularly like are Lanaquarelle and Canson 100. Other good brands are Winsor & Newton, Arches and Waterford. There are many more brands, so experiment with as many as you can.

properties of watercolor paper

Tooth: The surface texture of the paper. Rough paper has the most tooth; cold-pressed is a bit smoother, and hot-pressed paper is the smoothest.

Sizing: The coating on paper that determines how readily the surface absorbs water. Hot-pressed paper has more sizing to give it a slick, crisp surface. Most brands of cold-pressed and rough papers have less sizing.

Weight: The paper's thickness. The most common weights are 140-lb. (300gsm), which is fine for most work, and 300-lb. (640gsm), which is nice for larger pieces and buckles less.

Color: Paper can be cream white or a brighter blue-white. Some papers are even made in pastel colors.

tip

Tips for Working With Watercolor Papers

- Hot-pressed is the best choice for combining watercolor and colored pencil. Smooth washes are easier to achieve on cold-pressed paper; hot-pressed paper tends to grab and hold the paint, creating hard edges.

- When using hot-pressed paper, you'll get more even washes if you wet the paper before laying in color.

- For detailed information on how to keep paper from buckling, refer to *The Flat Wash* on page 36.

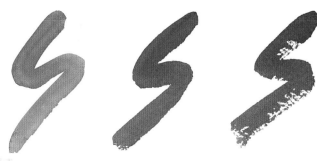

Hot-pressed Cold-pressed Rough

Watercolor Paper Samples
Notice how different a stroke of Prussian Blue looks on different watercolor paper surfaces.

Brushes are the most important tools you will use in painting. Beginners who are on a tight budget will do better buying less expensive paints and spending a little more on better brushes and paper.

That said, do we use all-sable brushes all the time? Absolutely not. Go with natural-hair brushes for smaller sizes and synthetic ones for larger sizes. You'll save money, and you'll also get better performance, as natural hair tends to wimp out and lose spring in larger sizes.

What You Need

Brushes come in round and flat shapes. Variations include the aquarelle (which has a scraper handle) and the oval wash (which is like a pointed flat). Here is a list of brushes to start with:

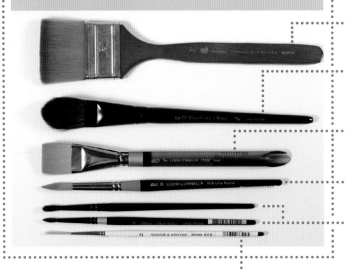

2-inch (51mm) synthetic wash (inexpensive is fine)

¾-inch (19mm) oval wash

¾-inch (19mm) or 1-inch (25mm) aquarelle flat (inexpensive is fine)

No. 10 round (natural hair if you can afford it)

Nos. 6 and 4 sable or synthetic round

No. 2 natural or synthetic liner

other handy tools

- Waterproof board (such as Plexiglas or Gator board)
- Water bucket (we use a three-section bucket purchased in the fishing tackle department at a discount store)
- White palette with at least eighteen wells and several spaces for mixing
- Synthetic kitchen sponge

- Natural sponges in different sizes
- Pump spray bottle
- Masking fluid and old brushes
- Hair dryer to speed drying time
- Paper towels
- Artists' white tape
- Pencil and eraser

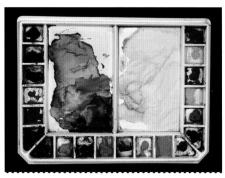

Medium-Sized Plastic Palette

Other Watercolor Tools

gouache

This medium's funny name is pronounced "gwash" (it rhymes with "wash"). Gouache works beautifully with colored pencil. Being water-based, it can be used straight from the tube for an opaque look, or it can be thinned with water for transparent, watercolorlike glazes. Used opaquely, it can cover errors.

what is gouache?

Gouache is simply opaque watercolor. Chalk is often the ingredient used to make gouache opaque.

properties of gouache

Opacity: Light colors of gouache can be painted over dark colors with great covering power.

Liftability: Dried gouache lifts easily—more easily than transparent watercolor. This makes layering tricky (see "Tips for Working With Gouache," below) but can be an advantage when you want subtle color and value changes.

Finish: Gouache colors have a richness of color because they are opaque. Gouache dries with a nice matte finish.

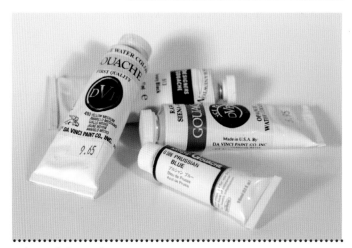

Tubes of Gouache

What You Need

We use Da Vinci, Holbein and Winsor & Newton gouache with excellent results. Brands can be mixed with no ill effects. The colors shown here would make a good starter set.

| Red | Yellow Medium | Cerulean Blue (Hue) |
| Burnt Sienna | Burnt Umber | White |

tip

Tips for Working With Gouache

• Since gouache is very liftable, make sure when layering that the first layer is dry, and put the second layer on with only one or two strokes and very little pressure.

• If you put colored pencil over gouache, lifting the gouache will remove most of the colored pencil. If you put gouache over colored pencil, you can lift the gouache without disturbing the colored pencil. Gouache can go over colored pencil as long as the latter hasn't been burnished to a slick surface.

• Colored pencil, being wax- or oil-based, can act as a resist for gouache if you apply the colored pencil thickly with plenty of pressure.

the flat wash

The first watercolor technique to try is the basic flat wash, in which the color is laid down evenly across an area.

Most watercolor paper will buckle at least a little when wet. We'll use this flat wash exercise as an opportunity to show you how we deal with the buckling problem. Most watercolor books will describe some method of attaching your watercolor paper to your board: either tape, glue or staples. Call us lazy, but when we discovered how well a piece of acrylic sheet works (thank you, Catherine Anderson), we were hooked and never stretched a piece of paper again. By balancing the amount of water on the front and back of the paper, you avoid buckling without the need for staples or tape.

materials

Watercolor Paint
Cobalt Blue

Brushes
2-inch (51mm) flat wash brush

Surface
140-lb. (300gsm) cold-pressed watercolor paper

Other
Acrylic sheet (Plexiglas or other brand), water bucket, rags; palette or plate for mixing

1 Prepare the Paint and Wet the Paper

Prepare your paint mix first, adding enough water to make a runny mix. It can be as pale or as strong as you like.

Use a piece of acrylic sheet that is several inches larger than your paper. Wet the front and back of your paper with a large wash brush. Lay it down on the acrylic sheet and you will see it start to adhere. Wipe the excess water from around the paper with a rag. Make sure there is no puddling that can run back onto the paper.

Apply your wash mix with a 2-inch (51mm) flat brush, working from top to bottom with overlapping horizontal strokes.

2 Smooth the Color

Use a rag to remove any puddles around the paper. Smooth out the color with your brush. Again use a rag to remove any puddles from around the edges of the paper.

3 Let It Dry

Let the paper dry on the acrylic sheet.

tip

If you do not need a wash over the entire picture surface, use this general guideline:

When putting paint on one-third or more of the paper, wet the entire back first to balance the wetness and help the paper adhere. If you are not working that large an area, or if you are working on details and not using much water, it is not necessary to wet the back. If some buckling does occur, wet the entire back and let it dry. This method works for any medium used in a watercolor fashion, such as acrylic washes, ink, gouache, etc.

When I need an absolutely, perfectly flat wash, I use 300-lb. (640gsm) paper, but this is rarely necessary.

the graded wash

The graded wash is sometimes called a gradated or graduated wash. Unlike a flat wash, the color and value change from top to bottom. You lighten the color by using less paint with each successive stroke.

materials

Watercolor paints
Da Vinci: Burnt Umber, Prussian Blue

Brushes
2-inch (51mm) wash brush, no. 4 round, no. 2 liner

Surface
Cold-pressed watercolor paper, 140-lb. (300gsm)

Other
Kneaded eraser, graphite pencil, paper towels, pump spray bottle, rags, sponge

Reference Photo

1 Do a Graded Wash, Then Lift Out Some Color

Wet both sides of the paper with a wash brush and clean water. Using a rag, wipe away any puddles from the board around your paper so that they do not run back onto your piece. Place the paper on your board with the top pointing toward you.

Mix a thin, light wash of Prussian Blue. Apply a generous amount of paint with the wash brush to the far end of your paper, stroking all the way across. Add a small amount of paint to your brush and repeat the stroke just below the first one. Clean the brush with water and, without adding more paint, stroke across the paper just below the second stroke, bringing color down onto the clean part of the paper. Continue to place strokes, cleaning the brush between each stroke, working down until a light layer of paint is carried to the bottom.

Use a dry paper towel to pull some color out of the center of the wash area. Let the painting dry completely.

2 Paint the Waves

After the paper is dry, lightly draw the subject on top of the wash. Mix a wash of Prussian Blue slightly stronger than the mix from step 1. Wet the front of the paper and sponge it until the shine is gone. Use a small round or liner brush to paint lines across the water. If the lines look too hard-edged or strong, spray them lightly with water to help the color spread. Let dry.

3 Add Rocks

Mix a medium-value puddle of Burnt Umber and paint all the rocks with this mixture and a no. 4 round. Be sure to avoid the areas where water puddles show through the rocks. Refer to the photo and drawing. It is not important that this application of color be even; the colors and values in the rocks vary, and so should your washes. Let everything dry.

4 Paint the Dark Values

Mix Burnt Umber and Prussian Blue to a cool (leaning toward blue), dark color. Mark with a graphite pencil the areas on the rocks to be left as highlights. Brush the dark mixture over all the rocks, painting around the highlight areas. Add some smaller rocks. Before the paint dries, clean your brush and soften the edges of the highlights by placing the brush tip on the light areas and wiggling it gently. Let dry, then add another layer of color to anything that needs a darker value.

Add water and more Prussian Blue to the mix you used for the rocks. Paint in the thin lines of waves in the water. Using a pale mix of Prussian Blue, paint in the rock shadows on the water in the foreground. It is better to start light; you can always add another layer. The warmer wave lines should be near the horizon, and the shadows on the water near the foreground should be cooler. Add a few tiny rocks to areas in the foreground with the mix of Burnt Umber and Prussian Blue. When everything is dry, erase the pencil lines.

tip

As long as the paper stays wet, you can adjust the color anywhere on the surface of a graded wash by adding more paint or by pulling off color with a clean brush. When the paper begins to dry, you must stop adjusting or risk ruining your wash.

masking for watercolor

Masking lets you temporarily prevent areas from being painted. Never use a good brush to apply liquid mask; use an inexpensive one and prolong its life by dipping it in soapy water before masking.

Reference Photo
I cropped the photo as shown and also moved the branch to the right for a more interesting composition.

materials

Watercolor Paints
Da Vinci: Aureolin, Burnt Sienna, Phthalo Turquoise, Sepia

Brushes
Wash brush, small round brush; inexpensive masking brushes (1 medium round or flat and 1 small round)

Surface
140-lb. (300gsm) cold-pressed watercolor paper

Other
Two small dishes, liquid soap, masking fluid, rubber cement pick-up; plastic toothpicks (optional)

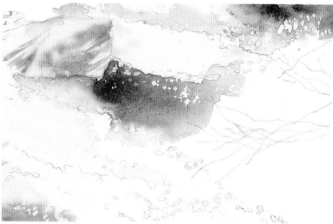

1 Draw, Then Mask

Lightly draw the subject on your paper. Use a kneaded eraser to clean smudges from your paper and soften any dark lines.

Squirt a little soap in one dish and mix in approximately twice as much water. In the other dish, pour a little masking fluid. Dip an inexpensive brush in the soapy water and then in the mask. Cover the whitewater areas with mask. Using a tiny round brush or toothpick, mask dots around the larger areas of white foam. These are not marked on the line drawing; use the photo as a guide. Let dry completely.

2 Add Sepia and Burnt Sienna

With plain water, wet the rock shadow and the upper-right and lower-left corners of the picture. Drop a medium-value Sepia wash into the rock shadow and in the top right corner. Place some Burnt Sienna just under the Sepia in the top right corner. Wash areas of Sepia and Burnt Sienna in the lower-left corner. Wet the rock and put both Sepia and Burnt Sienna on it, creating rock striations. Dilute the Sepia and Burnt Sienna to pale values, then paint the light area at the bottom of the rock below the water. Let everything dry, then mask the rock above and below the water, using your masking fluid and the technique from step 1. Let dry.

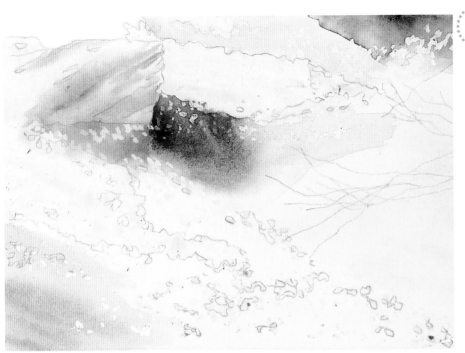

3 Deepen the Colors

Wet the back of your paper, then wet the front completely. Mix a strong value of Aureolin and wash it in, starting from the far right. Fade the yellow as you go left by lifting off some color with a clean, damp brush. Do not add more water to lighten the yellow; it will create runs and uneven edges when dry. Do not fade back to white; keep some yellow in all parts of the wash. If you have trouble getting a soft edge, lift the paper and tilt it in various directions to make the color run. You can also pull the yellow back toward the right with a clean damp brush. Let dry.

4 Remove Masking and Add Final Colors

Mix a medium-value wash of Phthalo Turquoise. With your wash brush, wet the entire back and front of your paper and wash the turquoise on all over. Go back and dab on extra turquoise on the water in front of the rock. Let everything dry completely. If you feel it is too light when dry, you can rewet and repeat the wash.

When the painting is dry, remove all masking with a rubber cement pick-up. If the mask lifts some color from the rock, put lines and crevice shadows back in with Sepia and Burnt Sienna. Use a small brush on dry paper to detail some of the lines.

Soften the edges of the whitewater with a light value of Phthalo Turquoise. You can do this in two or more layers if you are not sure how much color to use. Paint in the branches with a dark value of Sepia and as few strokes as possible. Let dry, then erase the remaining pencil lines.

wet-into-wet watercolor

Approach the wet-into-wet technique with an "anything goes" attitude. Wet paint on wet paper can be managed, but not controlled, so relax and enjoy the ride.

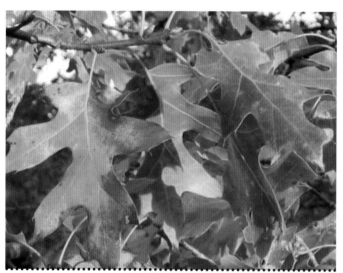

Reference Photo

materials

Watercolor Paints
Da Vinci: Arylide Yellow, Burnt Sienna, Quinacridone Red, Sap Green, Ultramarine Blue

Brushes
2-inch (51mm) wash, 1-inch (25mm) flat, inexpensive masking brush (tiny round), nos. 2 and 4 round

Surface
Canson 100 watercolor paper, one-eighth sheet (5½" × 7½" [14cm × 19cm]) (smooth side)

Other
Graphite pencil, kneaded eraser, masking fluid, rubber cement pickup; plastic toothpicks (optional)

1 Wash In Color, Then Do the Drawing

Before you draw the subject, do your first layer of color. Mix a fairly strong-value wash of Arylide Yellow. Wet the back of your paper, then the front with the 2-inch (51mm) flat brush. Wash the yellow in without concern for consistent coverage. Let it flow where it wants to, stronger in some areas and lighter or even white in others. Pick up your paper and move it in different directions to blend and smooth the edges.

Let the paper dry completely, then do the drawing. Use a kneaded eraser to soften lines and pick up excess graphite. Mask the leaf stems and veins with a tiny round inexpensive brush or with toothpicks. Let dry completely.

2 Drop In Green

Mix a medium-value wash of Sap Green and water. Wet the back of your paper with the wash brush and then wet only the green leaf areas on the front of the paper. Drop in the green with a no. 4 round, then pick up your paper and move it around to direct the flow of the paint and water. The paint will flow only within the wet areas of the paper. Again, do not be concerned about perfection. Let yourself "go with the flow" and be flexible about the finished product. Let dry. Save some of the Sap Green wash for step 4.

3 Deepen the Colors

Mix a strong wash of Quinacridone Red with a tiny amount of Ultramarine Blue. Wet the back of your paper with the wash brush and then wet only the red areas on the front. Drop the red in the darkest areas first with the no. 4 round, and then move the paper to let the paint flow into the wet areas. While the paper is still wet, drop in some Burnt Sienna along the edges of the darkest areas. Again, move the paper and let the color flow and blend. Don't try to force the paint to go where you want it. Lay the paper back down, then touch some of the Burnt Sienna to the buds on the branch. Allow everything to dry completely.

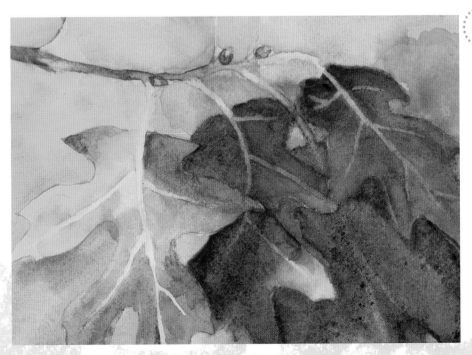

4 Remove Masking and Add Final Colors

Remove the masking with a rubber cement pickup. Mix a medium-value wash of Burnt Umber and paint in the shadows on and between the leaves. Also paint the tree branch with the Burnt Umber. Lift some of the paint on the branch with a wet brush to soften the effect. Let dry.

Darken the leaves with another layer of Sap Green. This time, mix the Sap Green with a little Burnt Sienna before applying it to wet paper. Let the colors run over the lines into other areas. Use your judgment and experiment with adding touches of color in wet areas here and there. Let everything dry completely.

gouache layering and lifting

The velvety look of gouache makes it the first choice for many artists. Others use it in conjunction with transparent watercolor. Gouache makes an excellent surface for applying colored pencil.

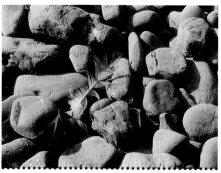

Reference Photo

materials

Gouache
Da Vinci: Burnt Umber, Cerulean Blue Hue, Payne's Gray, Raw Sienna, White, Yellow Medium

Brushes
Assorted small flats and rounds

Surface
Hot-pressed or cold-pressed watercolor paper, 140-lb. (300gsm)

Other
Graphite pencil, pump spray bottle of water (for misting the palette), tissue

1 Draw, Then Paint the Shadows

Lightly draw the shapes on your paper. Dilute some Payne's Gray gouache with water and paint a fairly thin layer to block in all the darkest areas between the rocks and the darkest shadows on the rocks. For the lighter shadow areas, add more water to the paint.

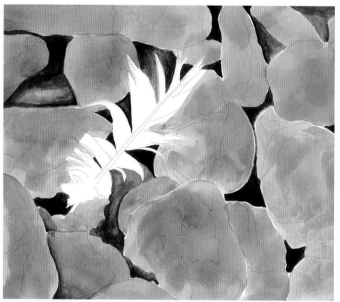

2 Paint the Rocks

Mix Burnt Umber and Cerulean Blue Hue for a gray color. If you want a warm gray that leans to the brown, mix more Burnt Umber than Blue. If you want a cooler gray, add more Cerulean Blue Hue to the mix. Wash this gray over all the rocks, avoiding the feather area and the Payne's Gray shadows. This layer should be thin enough that you can see the pencil lines through it. If you lose any of your lines, redraw them when the wash is dry.

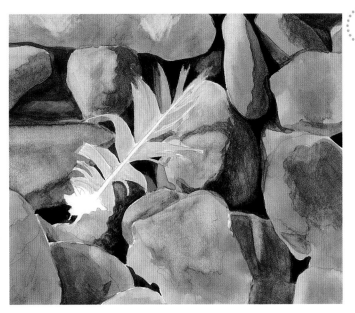

3 Paint the Rock Shadows and Feather

Mix Payne's Gray and Cerulean Blue Hue and wash in the cool shadows on the rocks. Next, using a clean, damp, round brush, rub the areas where sunlight is hitting the rocks and then lift with a tissue.

Up until now the paint has been very thin, almost like a watercolor wash, but now it's time to work with a thicker paint. Mix Payne's Gray with a little water to the consistency of heavy cream and layer this into the darkest shadows between the rocks. Mix a bit of Cerulean Blue Hue with the Payne's Gray to cool it, then soften the edges of the deepest shadows between the rocks. If the paint is dry in these areas, don't be afraid to use some pressure with the brush to move the paint around.

For the feather, mix Raw Sienna and White with a hint of the gray-and-blue mix to tone it down. Use this to do a wash over all of the feather except the bottom portion, where it's white and fuzzy.

4 Finish the Rocks and Details

To create edges on the rocks where light turns to shadow, take a clean, wet round brush and wiggle the brush in a zigzag along the edge of the shadow. You want to lighten a little bit and make the edge irregular.

Now you get to really punch up the values with more opaque layers of paint. Starting with the rocks, use White gouache to drybrush in the lightest areas of the rocks. For warmer lights, add some Yellow Medium or Raw Sienna to the White. Don't worry if the white doesn't seem light enough. You can always add another layer. If you think some areas aren't dark enough, go over them again with your gray mixtures. Adjust values back and forth until you are satisfied.

For a finishing touch, add the little speckles on the rocks with your smallest round brushes. Again using your smallest brushes, thin some Payne's Gray paint with water and give some fine lines to the feather. Don't forget the shadow lines under the feather where it hits the rocks.

don't fear "the ugly stage"

The most relaxed stage of a painting is when you've just begun and haven't made any mistakes yet. Then you start to rough in—and right after that, the "ugly stage" hits. Most painters are familiar with it. Don't be discouraged. You haven't done anything wrong; you just haven't gotten to the detail work yet. Keep going, and you will be rewarded.

Acrylic paint can do many of the things that watercolor can do, only better. It can be used on many different surfaces and, when used as a wash, behaves very much like watercolor. It is very compatible with colored pencil when used on a surface appropriate to pencil.

Tubes and Jars of Acrylic Paint

what is acrylic paint?

Acrylic paint is made by combining pigment with an acrylic polymer emulsion. An emulsion is a combination of two substances that do not ordinarily get along with each other, such as oil and water. In this case, it is acrylic polymer and water that make up the incompatible mix. When acrylic paint dries, the water evaporates, reducing the space between the polymer molecules and bonding them to each other. This is why acrylic used in a thick (impasto) manner can shrink a little and darken somewhat. When used in wash techniques, these effects usually do not occur.

what you need

Like watercolor and most other mediums, acrylic is produced in student as well as professional grades; most manufacturers make both.

The best way to use acrylic in combination with colored pencil is in a watercolor manner on paper. Fluid acrylics make the best washes. Fluid acrylics are thinner than regular acrylic paint (sometimes called *heavy body*), but fluid acrylics have the same pigment load. The colors are strong and do not require a large quantity to make a brilliant wash. There are several good brands of fluid acrylics, including Golden and Lascaux. Liquitex also makes a good fluid acrylic; its name recently changed from *Medium Viscosity* to *Soft Body*. Different brands may be used together with no negative effects.

Shown here is a good starter palette for acrylics.

Quinacridone Red Hansa Yellow Opaque Cobalt Blue

Quinacridone/ Nickel Azo Gold Jenkins Green Payne's Gray

properties of acrylics

Transparency/Opacity: Acrylics can be thinned with water for transparent washes or used in an opaque manner. With opaque applications you can cover a mistake completely. As with watercolor, some colors are more transparent than others. Most manufacturers indicate transparency on the label and/or in their color charts. This information is particularly useful when using acrylic in washes.

Permanence: Acrylic cannot be dissolved once it's dry, so it's permanent. No worries about lifting previous washes when layering.

Color change: When acrylics are used like watercolors they experience very little color change from wet to dry, so it's easy to predict what a finished wash will look like.

tip

Tips for Working With Acrylic

- Remember, acrylic is permanent; do not expect to lift acrylic colors after they dry.

- Acrylic washes can be layered just like watercolor; however, do not use it too thickly, because the paper will be sealed with a heavy coat and will not take any more washes. Also, colored pencil will not adhere well to a thick, slippery coating of acrylic.

- Color mixing is very similar to watercolor and should be limited to two transparent colors to avoid muddiness.

- When using hot-pressed paper, remember to wet it first. This is especially true when using acrylic; it will grab the paper and never move again. Wetting is not always necessary with cold-pressed paper.

- Acrylic and watercolor can be used together on the same piece. Use acrylic for the first layers, which will be permanent; then use watercolor for subsequent layers. This way you can lift, adjust and otherwise manipulate the watercolor after it dries.

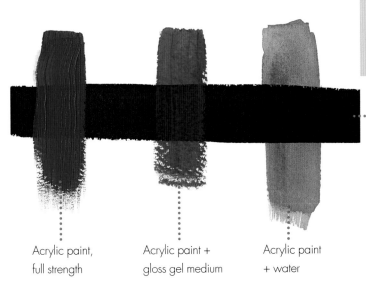

········ India ink

Acrylic paint,
full strength

Acrylic paint +
gloss gel medium

Acrylic paint
+ water

Acrylic Paint From Opaque to Transparent

Here are swatches of acrylic paint over a stripe of black ink. By itself, the paint is thick and opaque. Acrylic mixed with gloss gel medium is less opaque. Mixed with water to form a wash, acrylic paint becomes as transparent as watercolor and can be used to achieve watercolor-like effects.

surfaces

When painting with acrylic washes, watercolor paper or any surface that accepts wet mediums will work, including illustration board, watercolor canvas and many others.

Save scrap paper and test colors before putting acrylic paint on your good paper.

brushes

Watercolor brushes work well for acrylic when the acrylic is used in a watercolor manner. However, acrylic is much harder on brushes than watercolor, so do not use your best sable or other expensive natural-hair brushes. Use synthetic brushes and wash them with brush soap after each use.

Refer to page 34 for information on testing brushes before purchasing.

what you need

Paper: Refer to chapter three for samples of specific papers and boards. Try any and all surfaces to see what suits your particular needs.

Synthetic Brushes: Below is a list of suggested brushes to begin with. You'll also need brush soap.

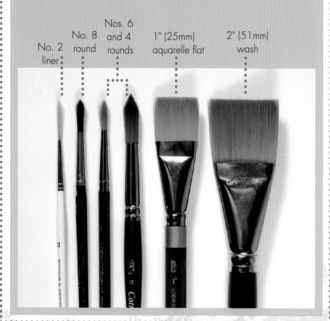

No. 2 liner · No. 8 round · Nos. 6 and 4 rounds · 1" (25mm) aquarelle flat · 2" (51mm) wash

Pink Magnolia
Kelli Money Huff
Acrylic and colored pencil on Lanaquarelle HP watercolor paper
3¾" × 8" (9.5cm × 20cm)

what you need

Palettes: Acrylic paint will stick permanently to a watercolor palette, so look for palettes made especially for acrylics. Usually these are white plastic with a lid that seals and a sponge or other method of keeping the paint wet. You can also buy disposable palettes that resemble a pad of waxed paper. Or you can try our favorite solution: white plastic plates (see the tip on this page!).

Board: You can use Gator board or any waterproof board. We use Plexiglas (or other brands of acrylic sheeting).

Water container: Our favorite bucket has three sections; we bought it in the fishing department at a discount store.

Synthetic kitchen sponge: Use a medium-size rectangular sponge to remove excess water from your brushes.

Natural sponge: Use several small shapes and sizes to create interesting textures.
Spray bottle: Use a small pump rather than the trigger type.
Liquid masking fluid and old brushes.
Hair dryer to speed drying time.
Artist's white tape for taping down paper masks.

tip

We like to use plastic plates as acrylic palettes. Always use white plates (we rarely use the words *always* or *never*; in this case, it's necessary). Colored plates will interfere with your ability to judge color and value.

You can buy white plastic plates at party supply stores. White foam plates do not last as long as plastic ones, but unlike the plastic plates, they are available at grocery stores. Paper plates are not a good substitute because they will absorb and waste your paint.

Acrylic palette with lid
Pump spray bottle of water
Masking fluid
Inexpensive brushes for masking
Eraser
Artist's white tape

Painting and Masking Materials for Acrylics

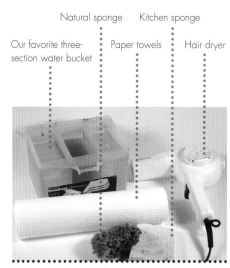

Natural sponge Kitchen sponge
Our favorite three-section water bucket Paper towels Hair dryer

Other Supplies for Acrylics

acrylic washes and glazing

Note: In some locations, Golden fluid acrylics are not readily available. As a second choice, use any brand of fluid acrylics with comparable colors, and as a third choice, use any brand of regular, heavy-body acrylics in comparable colors. Make sure the regular body acrylics are thoroughly mixed before using.

Reference Photo

materials

Fluid Acrylic Paints
Golden: Burnt Sienna, Cobalt Blue, Raw Sienna, Raw Umber, Red Oxide

Brushes
Synthetic brushes only: 1½-inch (38mm) or 2-inch (51mm) inexpensive wash brush, small round brush with a good point, medium round brush; inexpensive flat brush for masking

Surface
Canson 100 watercolor paper, one-eighth sheet (5½" × 7½" [14cm × 19cm]) (smooth side)

Other
Graphite pencil, kneaded eraser, paper towels, masking fluid, rubber cement pickup

1 Draw, Mask, and Paint the Sky

Draw the rocks lightly on your paper. With a kneaded eraser, clean up smudges and lighten any lines that will show through pale washes. Mask the top half of the rocks with masking fluid and an inexpensive flat brush. Let the mask dry, then mix Cobalt Blue with water to a medium value. Wet the back of the paper, then the front sky area; remove any puddles around the edges of the paper. Wash the Cobalt Blue into the sky with a 1½-inch (38mm) or 2-inch (51mm) inexpensive wash brush and smooth it out. After this dries, add another wash if you need to deepen the value. Let dry.

2 Remove the Mask and Start the Rocks

Remove the mask with a rubber cement pickup. Prepare pale washes of Burnt Sienna and Raw Sienna. Wet the back of the paper. On the front of the paper, wet all the rocks and ground below them but leave the sky area dry. Remove any puddles around your paper. Put a layer of the pale Raw Sienna mix over the entire rock and ground area. While this is still wet, drop in the Burnt Sienna where the rocks appear to be a coral color. Before it dries completely, remove color from the lighter areas with a clean damp brush. Let dry.

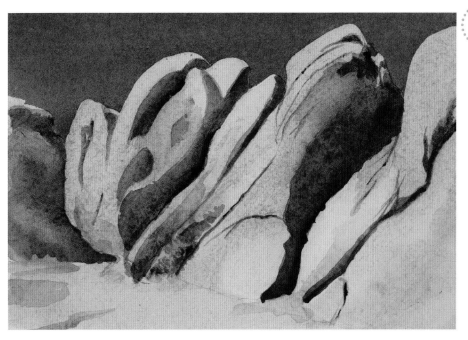

3 Add Color to the Rocks

At this point, if you have lost your lines, sketch them back in lightly before moving on.

Wet only the rocks on the front of your picture, and drop in a light wash of Red Oxide where the rocks are coral-colored. While this dries, mix a wash of Raw Umber that is darker than your previous mixes. When the previous wash is dry, use the Raw Umber mix on dry paper to color in the dark shadows of the rocks with a medium round brush. Notice where the shadows are hard-edged and where they have soft edges. Soften the edges by wiping them with a clean, damp brush. Use the point of the small round brush with the Raw Umber to draw in the areas where the crevices turn into lines.

Let the painting dry, then assess the colors and values. You will probably need to go back in to darken some areas. Pay attention to the differences in values and keep the variety; don't make them all the same.

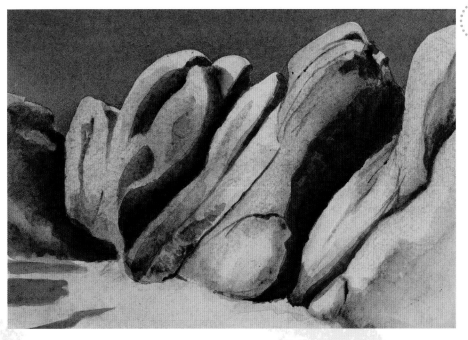

4 Paint More Layers As Desired

When I arrived at this step, I felt the red was still too pale and I decided I wanted more. The wonderful thing about acrylic is that because it is permanent, you can paint on top of previous layers easily and as many times as you want without disturbing anything. If you want more red in your painting, wet the rocks again and go back in with more Red Oxide. While that dries, add another layer of light Raw Umber to the foreground.

Let everything dry, then use Raw Umber to darken the shadows on the ground and any rock shadows that need it. Use a light Raw Umber mix to add a little texture on some areas of the rocks, using the photo as a guide. You can add as many layers as you want; just be careful not to lose the light values.

ink

Ink is exciting to use because, unlike watercolor, it keeps its brilliant color even after drying. Using ink can be very similar to painting with acrylic washes. Use it much as you would watercolor, but always be aware of its permanence. Remember to check the label for the designations *lightfast* and *waterproof*. The word *permanent* on the label is not enough.

Inks and Brushes

what is ink?

Ink is made of a base plus a coloring agent. Several types of bases are used for making ink; two of the most common are acrylic and shellac. The coloring agent can be either pigment or dye. Pigments will not fade with time; dyes will. Acrylic-based inks and those with pigments are more permanent.

what you need

The ink we will be using is in liquid form, and usually comes in a glass bottle. Check the label to see whether the ink you are buying is permanent. The label must read *waterproof* and *lightfast* in order for it to be permanent for artwork.

Ink rarely needs thinning, but use water when needed to lighten the color.

This selection of colors makes a good starter set.

Rose Lemon Yellow Process Cyan

Gold Ochre Sap Green Sepia

other tools for ink

- Synthetic brushes. Some artists like sumi or Chinese brushes
- An inexpensive or disposable palette. Try white foam plates or the white plastic plates available in the wedding section of party supply stores
- Bucket of water
- Sponge
- Paper towels
- Liquid mask
- Hair dryer to speed drying time

properties of ink

Transparency/Opacity: Inks may be labeled *opaque* or *transparent* depending on which brand you buy.

Body: *Body* refers to the viscosity or thickness of ink. Some inks are made heavier to use for monotype, print-making and commercial uses.

Permanence: *Waterproof* on the label means that an ink is made to stay put even if re-wetted.

Lightfastness: Look for inks labeled *lightfast* so that you can be assured your artwork will not fade with time.

tip

Tips for Using Ink

1. Never use your expensive sable brushes or your best palette with ink, as ink will stain.

2. Wash brushes with brush soap after using them with ink.

3. Even waterproof inks will release a little bit of color when re-wetted, but usually not enough to be a problem. If you aren't sure if an ink is waterproof, test it by painting a swatch, letting it dry, then going over it with a brushful of water.

4. Most inks need a good shaking before use. Make sure the cap is on tightly before you shake. That reminder may sound silly, but Kelli has lots of rose-colored ink on her studio floor, work table and a few books that says otherwise.

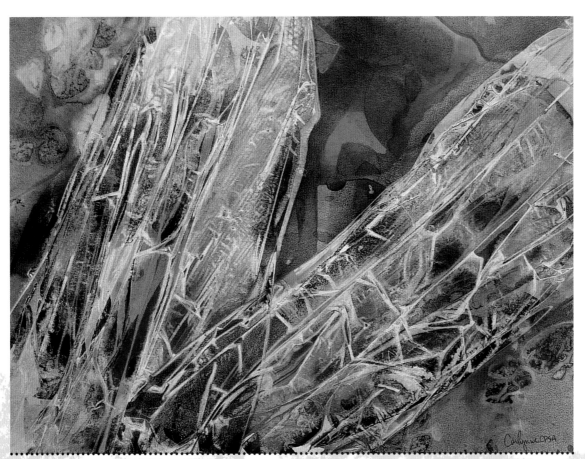

Wings
Carlynne Hershberger
Acrylic ink, watercolor and colored pencil on 140-lb. (300gsm) hot-pressed watercolor paper
11" × 15" (28cm × 38cm)

working with ink

Ink is a terrific medium for subjects that demand bold color. When painting with ink washes, dab your brush on a sponge to get rid of excess water. This will help strong washes stay strong.

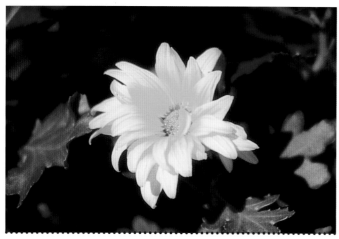

Reference Photo

materials

Inks
FW Acrylic Artists Ink: Lemon, Prussian Blue, Sap Green, Yellow Ochre
Dr. Ph. Martin's Tech Ink: Gold Ochre

Brushes
A selection of synthetic flat and round brushes

Surface
Canson 100 watercolor paper (smooth side)

Other
Graphite pencil, sponge, paper towels

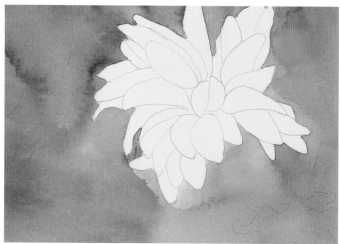

1 Wash On Yellow, Then Draw

Before you draw the subject, mix a fairly strong-value wash of mostly Lemon ink with just a couple of drops of Yellow Ochre. Add only a small amount of water. Wet the entire back and front of the paper with clean water. Paint in the yellow mix. This wash does not have to be even; much of it will be covered by subsequent layers. Let dry completely. If you want more color, repeat as many times as necessary, letting the layers dry in between. When the color is right and everything is dry, do the drawing on top of the wash.

2 Start the Background

Put some Sap Green on your palette. Wet an area about one-quarter of the way around the flower with clean water, using several brush sizes: larger on the outer areas of background, smaller near the petals. Brush the color into the wet area. Keep moving around the flower in this manner until the background is done. Do not be worried about any unevenness; variety is good. You will very likely have some hard edges within the green, but they will be covered by darker colors later. Let everything dry.

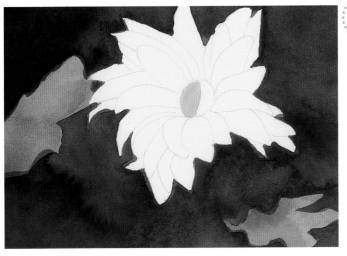

3 Darken the Background

Wet the back of your paper. On the front, wet the background around the flower petals. Using the same technique as in step 2, put another layer of color on the background, this time with Prussian Blue. Work your way around just as before, doing a section at time. Once again, try to get somewhat uniform color and value all around, but do not worry about unevenness; small variations will create the illusion of more leaves and flowers in the background. Let dry.

Next, wet the center of the flower, making sure it is just damp with no puddling. Drop in a small amount of straight Gold Ochre ink and let it dry. Wet the two leaves that show in the background and drop in a little Lemon and a little Gold Ochre. Let these colors mingle and dry.

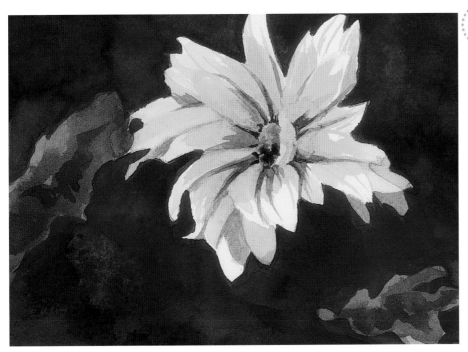

4 Finish

Do not wet the paper. Put Gold Ochre and Lemon on your palette. Keep some of the Lemon pure, but mix the Gold Ochre with a little bit of Lemon so that you have two different yellows. Using these two yellows, add shadows and lines in the flower petals. Use a small round brush and try to do each line or shadow in one or two strokes. If you need to darken a value, wait until it is dry and then go back in with more color.

For the darkest values, mix Sap Green and Gold Ochre and paint in the deep crevices between petals using a small round brush. You can also use this mix to add darker touches to the center of the flower.

To finish the background, add another layer of Sap Green over the blue, but this time, do not pre-wet the paper. Once again, do one section at a time and let each section dry for about 30 seconds, then blot each just once with a paper towel. This will vary the values in a softer way and show more variations in the colors as well.

On the leaves, add more green in the dark areas and shadows. Keep it loose; suggest shapes without adding much detail.

graphite

People sometimes think of graphite as just a sketching tool, but graphite drawings are wonderful works of art in their own right. There are several ways to use graphite with colored pencil. Some artists draw and shade a subject entirely with graphite, then cover it with color. You can also combine graphite with colored pencil in layering and blending. Many watercolor artists deliberately let their graphite lines show in finished paintings because they feel the lines are an important part of the artwork.

Tools for Graphite

what are graphite pencils?

People typically refer to "lead pencils" and "pencil leads," but in fact, writing and drawing pencils are made not with lead but with graphite, a type of carbon. The graphite is mixed with a clay binder to harden it.

what you need

Two of our favorite pencil brands are Faber-Castell and Tombow. They seem smoother and more consistent than some other brands. A good range to begin with would be 2H, B, 2B, 4B and 6B.

Other Materials and Tools for Graphite

Paper: Any drawing paper works with graphite. As with colored pencils, the smoother the tooth, the more even the tone you will get. Sketchpad paper is lighter in weight than paper sold as loose sheets, so it is not as durable for erasing but is otherwise fine. For "keeper" drawings, use acid-free or buffered papers to extend the life of your work.

Erasers: The same types of erasers that you use for colored pencil will work for graphite: vinyl, kneaded, stick and electric. Kneaded erasers are useful for removing smudges and for lifting out graphite to lighten values.

Erasing shield: This helps you erase in tight areas.

Sharpener: A good sharpener is a must. As for colored pencils, we carry a battery-powered sharpener to classes and use a corded electric model in the studio.

Blending tools: Tortillons and stumps are rolls of paper made to smooth and soften areas of graphite or charcoal. You can also blend with a chamois, tissue or soft brush.

Brush: A soft, clean brush whisks away crumbs without smudging your drawing.

Tracing paper: Use this for transferring drawings or resting your hand on to protect your work from smudges.

Fixative: Use workable spray fixative to reduce smudging while you work and final fix to add a protective finish. Test the spray on a sample of your paper to see what effect it may have.

properties of graphite pencils

Hardness: Drawing pencils from all makers have a range of hardness, with the softer ones containing more graphite and less binder. Most pencil brands have grades of hardness ranging from about 8H to 8B. Here is a sampling:

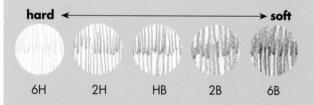

hard ←————————————→ soft

| 6H | 2H | HB | 2B | 6B |

The higher the number in H, the harder the pencil and therefore the lighter the mark. The higher the number in B, the softer the pencil, and the darker the mark. To remember, think of H as hard and B as black.

Wood/woodless: Graphite pencils usually are cased in wood, but they also come in woodless varieties which are just a thick lead with no casing. Woodless pencils are great for covering large areas, and they give you a lot more graphite for your money.

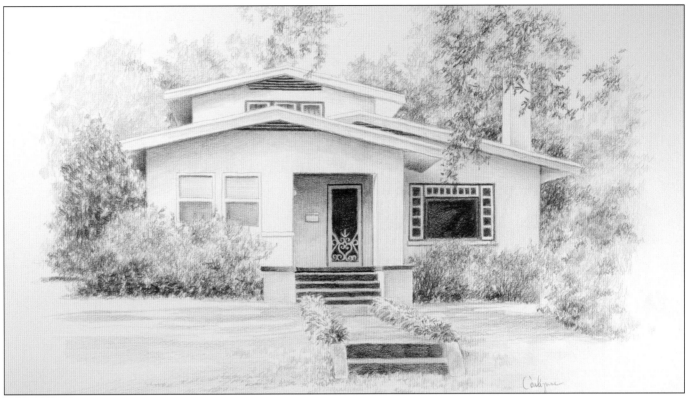

3rd Street
Carlynne Hershberger
Graphite
9" × 13" (23cm × 33cm)

blending stumps: two viewpoints

We almost came to blows over this one. Carlynne really dislikes blending stumps: "Students come to depend on them when they are introduced too soon, and they don't learn other techniques for achieving a variety of values in graphite work." Kelli counters, "Stumps are just another tool and can be used for interesting effects along with other techniques. And by the way, Carlynne, just chill."

tip

Tips for Working With Graphite

• Pushing harder on lighter-value, harder pencils will not make darker marks; you will simply damage the paper. When you want darker-value lines and shapes, move up the scale to a softer pencil. Keep in mind that the softer pencils tend to smudge more.

• One brand's H might be equal to another brand's B; therefore, you might find it helpful to stick to one brand in any given drawing, so that when you reach for the next pencil in line on the chart, you know you are making a change in the right direction.

• Spray fixatives, both workable and finish, are very helpful. Be sure to clean off any smudges before you spray.

graphite layering and lifting

In this exercise you'll practice achieving a variety of values with different grades of pencils. You will also blend and erase to create different effects.

Reference Photo

materials

Graphite Pencils
Tombow: 2H, 2B, 4B and 6B

Brushes
Soft mop or drafting brush for brushing away crumbs

Surface
Stonehenge paper, Warm White

Other
White vinyl eraser, kneaded eraser, stick eraser; electric eraser (optional); sharpener, small blending stump or tortillion, tracing paper

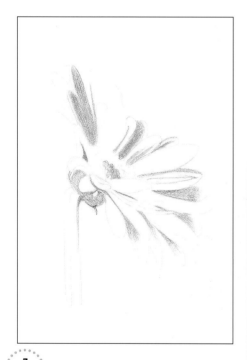

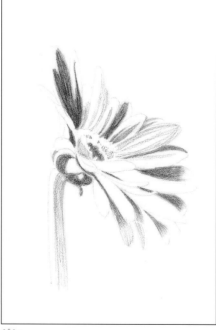

tip

In graphite drawing it is important to keep the paper clean. As you draw, use a piece of regular or tracing paper under your drawing hand to protect your drawing. Use a brush rather than your hands when dusting off paper to prevent smears.

1 Draw the Flower, Then Fill In the Darks

Lightly draw the outline of the flower on your paper with a 2B pencil. If your kneaded eraser is new, knead it into a ball. Press the kneaded eraser on the lines to remove excess graphite. With a sharp 2H pencil, lightly fill in the darker areas of the drawing. Establishing these darks first will help to give you a map to separate lights from darks as you go along.

2 Add Middle Values and Darken the Darks

Keep your pencil points sharp and stroke lightly; it is better to build up value slowly in the beginning. Find the middle-value areas and color them in with a B pencil. Use your stick and vinyl erasers to keep edges clean. With a 2B pencil, add a layer to the darks that you applied in step 1.

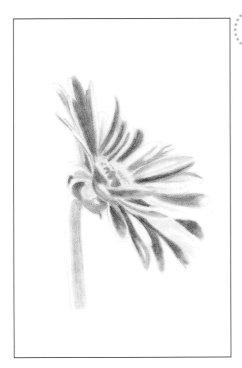

3 Blend, Then Darken More

Using a blending stump, rub the middle values to soften and even out the tone. Do the same to the dark values. At this point, your blender will have some graphite on the tip. Use this "dirty" blender to draw in the light values that are not really white.

Give the darkest values a layer with a 4B pencil; do not blend this time. Use the 2B to go over the middle values, without blending. Sharpen the edges of the darks with the 2B pencil. Use a stick or white vinyl eraser to clean up edges (an electric eraser, if you have one, will work even better).

4 Finish

Use the 2B and 4B pencils to make random vertical strokes in the background. With the kneaded eraser, press and lift all over the background area to create texture. Repeat with several layers. Keep turning your kneaded eraser in different directions as you press and lift, and knead it periodically.

Use the 4B to deepen the darkest areas of the flower, especially near the center. Clean up the edges—especially the light edges that meet the background—with the electric or stick eraser. Use the kneaded eraser to clean up white areas around the darker background.

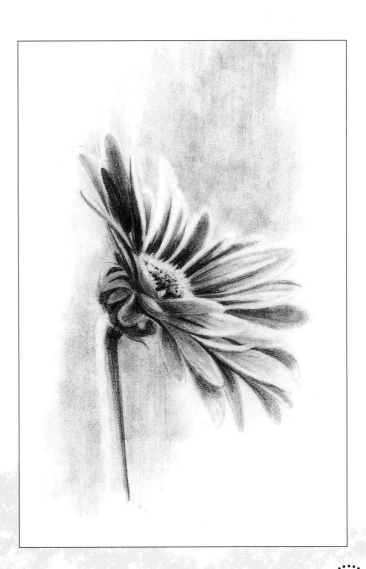

oil pastel

Oil pastels were originally designed for children. They were primarily a sketching tool for artists until around 1949, when Pablo Picasso asked the Sennelier company to create an oil pastel for professional artists.

Oil Pastels

what are oil pastels?

Oil pastels are sticks of pigment mixed with small amounts of wax and oil. Originally, oil pastels were made with vegetable oil, but today's products are made with petroleum-based oil so that they are acid-free.

properties of oil pastels

Hardness: Oil pastels are soft and dust-free, not chalky. They stay soft even after being applied to artwork. They vary in hardness depending on the brand.

Opacity: Oil pastels are thick and opaque when applied.

what you need

Besides Sennelier, other good brands include Holbein, Panda and Cray-Pas Specialist. Cray-Pas also makes a student grade called Expressionist. Most brands come in sets of various sizes. As with soft pastels, the more colors you have, the better. Try a few sticks from different manufacturers to see what works for you.

Oil pastels should not be confused with oil sticks, which are actually oil paint in stick form.

Other Materials and Tools for Oil Pastels

Surfaces: Oil pastels will stick to almost anything. Try them on a variety of papers such as hot- or cold-pressed watercolor paper, drawing and pastel papers. Also try canvas, Clayboard, Masonite, glass or sheet plastic, illustration board, bristol board or velour. Try as many surfaces as you can to make sure you don't miss a really great effect. Just make sure the surface is sturdy enough to take heavy pressure, which is sometimes required for application of oil pastels. Keep in mind that you might want a smoother surface if you will be combining oil pastels with colored pencils.

Blending tools: You can blend with vinyl erasers, typing erasers, stumps and tortillions. Rounded and chisel-tipped color blenders (sometimes also called color shapers or paint erasers) are sold for moving paint around on canvas. Mineral spirits and bristle brushes can be used to melt and blend color, especially for initial block-in layers. This works well but can leave unwanted brush strokes. You can also brush over oil pastel with a dry brush; it does blend, but the brush tends to pick up bits of oil pastel that clog the bristles.

Razor blades: Use these to remove color in order to rework an area or for a sgraffito (scratching) effect.

Templates, French curves and erasing shields: Use these to control the application of color and keep from contaminating areas with unwanted color.

Masking tape: Use this to mask off areas with hard edges.

tip

Tips for Working With Oil Pastels

- As you build layers, you can blend color smoothly or build the surface to a thick, textured, impasto look. Since oil pastels remain soft, you can go back to the artwork any time to add to or rework it.

- Try using oil pastel as a resist under washes of watercolor and acrylic.

- Try scratching the work with anything pointed: a golf tee, a dried-up ballpoint pen, kitchen utensils or a palette knife.

- Heat will melt oil pastels as well as colored pencil. Avoid heat when you don't want this to happen, or use heat to soften the pastels when desired. Warm the drawing paper in an electric pan, and the sticks will glide on the surface. You can also put the sticks in the microwave. It may take up to 1½ minutes at 100% power for a handful of colors. Be sure to watch the oven and check them periodically—you don't want them turning into soup!

- For firmer pastels, put them in the freezer. When working outside on a hot day, it is helpful to keep the pastels in a cooler with a cold pack.

- When combining colored pencil and oil pastels, use tissue to remove the buildup of oil pastel on the point of the pencil.

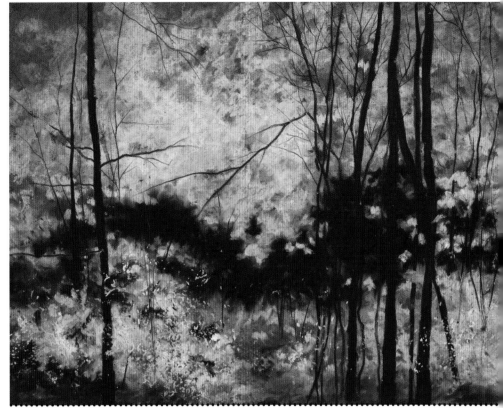

Autumn
Carlynne Hershberger
Oil pastel and colored pencil on
Canson Mi-Teintes
7" × 9½" (18cm × 24cm)

landscape reminder

It is not uncommon for artists to combine two or more reference photos for a painting. Sometimes when our students do this, we have to ask them, "How many suns does this planet have?" In a realistic landscape you must have only one light source. It's fine to change elements around for a better composition, but the light source is crucial to conveying your message, and it must be believable.

layering and blending oil pastels

This project will use oil pastels on a colored background. Thick oil pastel will hide whatever's underneath, so in this exercise, try to apply the pastel in a scumbling manner so that the rich paper color can enhance the painting.

materials

Oil Pastels
Blue (light, medium and dark), gray (light, medium and dark), white; an assortment of landscape colors such as yellow, yellow ochre, red, orange, cream, beige and various greens

Surface
Canson Mi-Teintes paper, Indigo Blue

Other
White pencil or transfer paper; paint eraser or color shaper

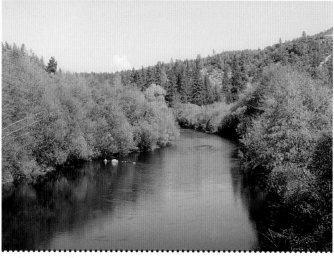

Reference Photo

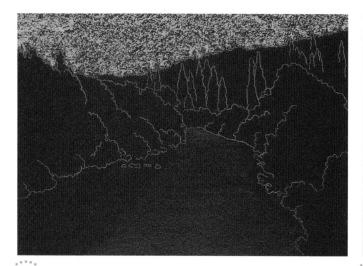

1 Draw, Then Begin the Sky and Water

Since you're working on a dark paper, use a white pencil or white transfer paper to get the drawing onto your surface. The pastel will obliterate the lines, so don't worry too much about getting the drawing perfect.

Beginning with your lightest blue pastel, rub color across the entire sky. Rub darker blue across the river area. Put down a little extra color at the top where the river disappears around the bend and at the bottom where it's closest to you.

2 Blend More Color Into the Sky and Water

Apply a layer of white oil pastel over the blue in the sky. The white will blend with the blue and smooth out the texture a little. Smooth the sky with a paint eraser. Now, move down to the water. Add a layer of dark blue at the top of the river where it narrows and at the bottom where the river comes forward in the picture plane.

3 Refine the Water and Begin the Trees

Rub some white horizontally across the water. Use the paint eraser to blend. Add some medium gray near the top on the water where the ripples have dulled the reflections. Keep working back and forth among dark blue, light blue and white until you achieve the desired gradations of color and value.

With a yellow ochre pastel, begin to lightly scumble in the trees. Let the dark blue paper work for you; where it peeks through, it will create the impression of texture and shadow areas. Keep the yellow ochre out of the shadow areas along the bottom of the trees where they hang over the water. On top of the yellow ochre, add some orange and yellow or cream.

4 Add Distant Hills and Finish

Apply muted grays and greens and beige for the distant hills, scumbling in vertical treelike shapes.

For the reflections in the water, use the same colors that are in the middle-ground bushes, but apply them with very light pressure. Use vertical strokes and drag the color down. The reflection is darker than the actual bushes, so leave plenty of blue paper showing. Rub the color with vertical strokes of the paint eraser, blending downward.

To bring the water ripples across the reflection, use light blue and light gray in horizontal strokes, then pull color across with the paint eraser.

Layer more yellow ochre, orange and yellow in the foliage. Keep the pressure light to preserve the wonderful rough texture.

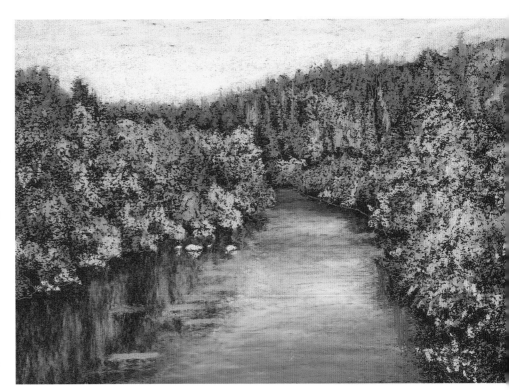

metal leaf

Metal leaf is incredibly versatile. The same product can be used on picture frames, crafts, artwork, home decor and many other surfaces. A word of warning: metal leaf can be addictive. When a little looks good, you tend to want to use it on anything and everything!

Metal Leaf and Tools

what is metal leaf?

Metal leaves are thin, delicate sheets of metal. Metal leaf is made in several different types, including genuine silver and 22-carat gold. Gold leaf has been used by framers for generations. There is also a less expensive type of leaf called composition leaf, in which the gold is really made of brass and copper and the silver is aluminum. There is even an edible leaf used in baking, made of 23-carat gold, in case you plan to eat your paintings.

what you need

Metal leaf is readily available at art and craft stores. In addition to gold, copper and silver colors, there is also variegated leaf, which has swirls of several colors running through it. It's great to have some of each color on hand because you never know when the need will arise.

Other Materials and Tools for Metal Leaf
Adhesive sizing: This is glue made for metal leafing. For artwork, the best type to use is water based; it cleans up with soap and water and dries fast. Adhesive sizing also comes in an oil-based type suitable for interior or exterior projects; this type requires mineral spirits for cleanup and takes more time to dry. Leafing pens, containing adhesive in a marker form, are also available; they work particularly well for small areas and lines.
Surface: If the adhesive sizing is used properly, metal leaf can be used on any surface you would choose for artwork.

Tweezers: Use these to lift the delicate pieces of leaf.
Very soft brush: You can pick up pieces of leaf with a brush, and you can also use it to rub across the surface after application to adhere the leaf and remove excess.
Sealer or varnish: A final sealer or varnish made for metal leaf protects your finished work from damage and prevents tarnishing. Read the label; these products must be used outside or in a well-ventilated area.
Inexpensive brushes: Use inexpensive brushes to apply the adhesive sizing and the sealer.
Mineral spirits: For cleaning the brush used for the sealer or oil-based sizing.
Dish of soapy water: Dip your adhesive brush into this before dipping it into the adhesive sizing to prevent the bristles from becoming gummy with adhesive.

Tips for Working With Metal Leaf

- Be careful if you have long fingernails; they can easily tear the delicate leaves.

- Do not breathe on the leaf or it will blow away.

- Rub your soft brush across your hand or cheek; the resulting buildup of static electricity will pick up the leaf.

- Always use a piece of leaf larger than the area you need to cover, then remove the excess.

- Hold your work over a trash can while you brush off the excess leaf in order to catch the pieces. If you want to keep these *skewings*, as they are called, for later use, hold your work over a large piece of paper while you brush, then funnel the bits into a jar.

- You can use more than one piece of leaf to cover a large area; they will blend together fine. Work in sections. If there are gaps in your leafing area, just add more sizing, wait for it to dry and add more leaf.

- The label on the brand of adhesive sizing we use says to let the sizing dry for an hour before applying leaf. We are not capable of waiting that long. We apply the leaf in a matter of minutes (or immediately) and have never had problems. Well, one problem: sometimes the sizing is a little slippery, so use care to avoid moving the leaf around on wet sizing.

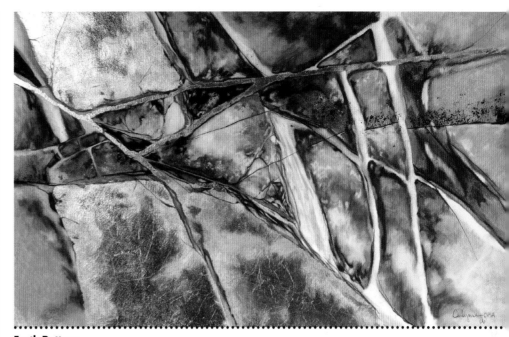

Earth Pattern
Carlynne Hershberger
Silver leaf and colored pencil on cold-pressed illustration board
11" × 19½" (28cm × 50cm)

what is it?

You may already be familiar with the term *representational art*, also called *realism*: It means art with an identifiable subject. But did you know that there is a difference between abstract art and non-representational art? *Abstract art* is based on a concrete subject that is stylized or changed in some way that makes it less identifiable. *Non-representational art* does not depict any concrete object. Non-representational work might be based on a color, a shape or a feeling.

metal leaf

In this exercise we have chosen to simply teach you how to use the metal leaf. You can apply this skill to any type of artwork. Absorbent surfaces, such as softer papers, may absorb your sizing, affecting the quality of adhesion. On such surfaces, apply the sizing, wait a few minutes, then reapply, as many times as necessary to get the right amount of tack.

1 Draw the Design
Draw the design on the red-toned paper using a white or gray pencil.

2 Apply Adhesive, Then Start Leafing
Give the bottle of adhesive sizing a shake (be sure to read the label). Dip an inexpensive small round brush into soapy water, then dab the excess onto a sponge or paper towel. With this brush, apply sizing to the narrower areas you want to leaf. Switch to a larger brush to apply sizing to the wider areas. The paper will absorb some of the glue, so wait a few minutes, then apply a second coat.

Now you'll apply the leaf, working one area at a time. Gently tear off a piece of leaf a little larger than the area you want to cover. Don't sneeze, cough or generally exhale with any exuberance, or bits of leaf will go flying everywhere. Drop the leaf onto the paper and tap it into place with your finger. Repeat until all areas are covered.

materials

Metal Leaf
Gold composition leaf; copper leaf

Brushes
Inexpensive small and medium round brushes
Large soft mop or goat hair brush

Surface
Canson Mi-Teintes paper, Red Earth

Other
Gray or white pencil, adhesive sizing, small dish of soapy water, satin sealer for gold leaf, odorless mineral spirits; sponge or paper towels

3 The Brush-Off

Use a big soft mop or goat hair brush to gently brush away the excess leaf. If you find some gaps where the leaf didn't stick (called *holidays* in gilding terms), repeat the sizing and leafing process in those spots.

Brush all metal leaf areas with sealer when finished. Clean the brush with odorless mineral spirits.

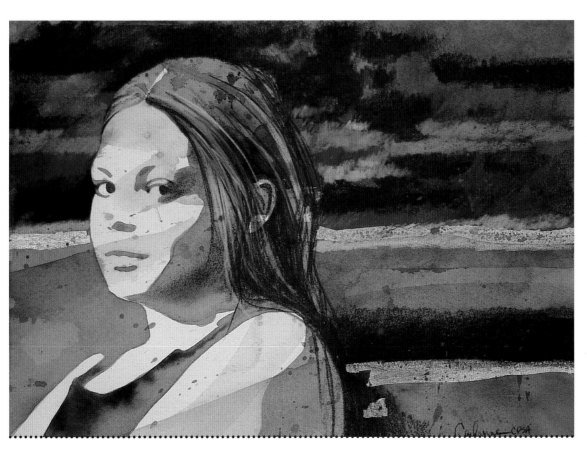

Metal leaf helps take this painting beyond the typical portrait to some otherworldly place.

Journey, Portrait of Kristen
Carlynne Hershberger
Watercolor, colored pencil and gold leaf on 300-lb. (640gsm) Lanaquarelle hot-pressed paper
11½" × 15" (29cm × 38cm)

rub 'n buff

Rub 'n Buff, made by Amaco, is a metallic product with a pastelike consistency that comes in small tubes. It's used for adding a metallic luster to frames and craft projects. Since it has a wax base, it works well with colored pencils.

what is rub 'n buff?

Rub 'n Buff is a wax-based paste with metallic pigment mixed in.

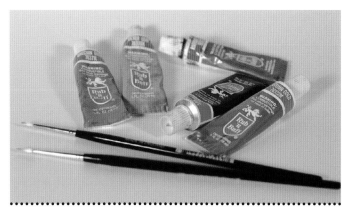

Tubes of Rub 'n Buff and Brushes for Application

tip

Tips for Working With Rub 'n Buff

- The simplest and most direct way to apply Rub 'n Buff is to squeeze some onto your finger and rub it onto the work. You can also apply the product with a rag for larger areas.

- Rub 'n Buff will adhere to both smooth and textured surfaces. On a textured surface, keep the pressure light and the metallic paste will skim the top of the hills, leaving the color in the valleys showing. This really highlights the texture.

- Rub 'n Buff is removable with an electric eraser. You can completely remove it and rework the area.

- Once the color is in place the way you want it, use a soft cloth to buff it to a sheen. Sometimes texture or other mediums may interfere with your ability to buff it, but that will not in any way diminish the beauty of the metallic effect.

- To get a linear effect, try working with a brush. Squeeze a little Rub 'n Buff onto a palette or plate. Dip the brush in odorless mineral spirits and mix with the paste. Thin it to the consistency of cream and use it like paint. Allow it to dry before adding other mediums.

what you need

Rub 'n Buff is commonly found in craft as well as fine art stores. It comes in many different colors, such as Grecian Gold, Autumn Gold, Antique Gold, European Gold, Silver Leaf, Sapphire and Pewter.

Other Tools for Working With Rub 'n Buff
Inexpensive synthetic brush: For applying the paste in a linear fashion (see "Tips for Working With Rub 'n Buff" on this page).
Rag: For applying the paste to large areas. Also for buffing the applied product.
Odorless mineral spirits: For thinning for brush application; also for brush cleanup.

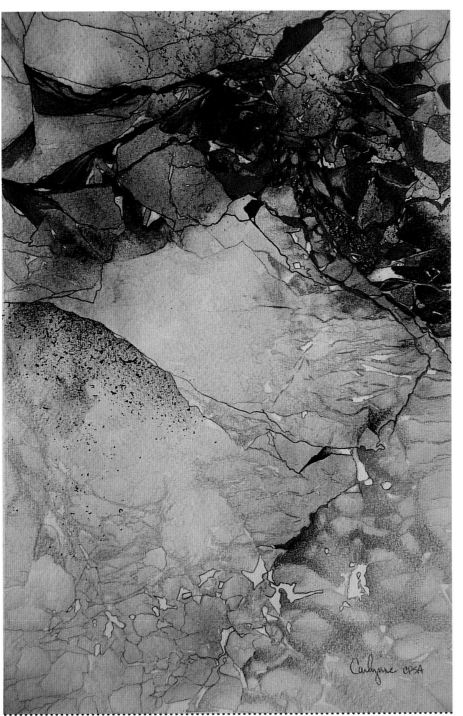

Prospecting
Carlynne Hershberger
Watercolor, colored pencil, Rub 'n Buff, crushed moonstone
10½" × 7" (27cm × 18cm)

monotype

A monotype is a single print, hand-pulled by the artist from a plate that has been inked or painted. Monotypes can be made with or without a press. As the name implies, only one print is made, since there is usually enough ink or paint for only one usable image. Sometimes a second or "ghost" print is pulled.

You might wonder why one should use a plate if there is only one print made; why not just paint directly on the paper? The print created has a different look than that which comes from direct painting. The monotype process creates wonderful textures and many surprises.

Monotype Plates and Tools
Shown here are two types of barens (the wooden spoon can substitute) along with acrylic sheeting and foam printing plates. The foam plate is etched with lines to create a pattern.

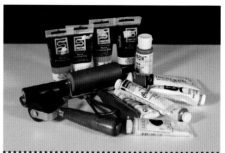

Inks, Paints and Brayers for Monotype

what you need

Monotype is one of the most flexible art processes because you can use many types of mediums separately or together. Almost any type of paint or ink can be used. Following is a partial list:

- Watercolor
- Gouache
- Acrylic
- The new Chroma Atelier Interactive slower-drying acrylic
- Oil
- Oil based printing ink
- Block printing ink
- Water-soluble crayon
- Createx monotype color

Other Materials and Tools for Monotype

Paper: Some papers are made especially for printmaking, such as Rives BFK, Stonehenge, Lenox and many others. Canson Mi-Teintes, a pastel paper, comes in many colors and works well with printmaking inks and drier paints. Rives BFK, Stonehenge and Lenox work well with all inks and paints. Asian papers are ideal for monotype due to their variety of colors and textures as well as their soft and flexible nature.

When choosing paper, remember that drawing papers are thin and lightweight and are not made for watery mediums, nor can they be soaked. However, they can be used with paints that are thicker and a little drier, such as oils or acrylics. Heavier papers and papers made for wet mediums such as watercolor and printmaking papers can be used with any medium and method. Smoother papers will do a better job of pulling ink or paint from the plate, but textured papers will create interesting effects. Lighter-weight handmade papers, particularly the smoother ones, work well for monotype. We have not listed every possibility here; be sure to try whatever you have access to.

Printing plate: This can be glass, acrylic sheeting, metal or any smooth surface.

Baren: A round, flat tool with a handle, used to press the paper against a printing plate or block to transfer a print. The bowl of a wooden spoon can serve as a substitute.

Tape: To attach the paper to the plate.

Poster putty: To hold the plate on the board.

Tracing or newsprint paper: For cover sheets to avoid getting paint on your tools.

Brushes and brayers: To apply paint to the plate.

Water or solvent: To thin paint and to clean brushes.

Retarders: To slow down drying so that you have more time to transfer a print.

the monotype process

You don't need to buy a press to make monotypes. The simple setup shown below ensures that multiple printing impressions will be properly *registered*, or aligned.

A piece of acrylic sheet serves as the printing plate. It's a good idea to bevel the edges of the acrylic sheet with a metal file before use. This results in an embossed edge similar to an etching plate, and it also prevents the edges from cutting your paper. You do not need to transfer your drawing to the printing paper. Just place the drawing under the acrylic sheet and use it to guide your application of ink or paint.

Printing paper (taped to plate)

Printing plate (secured to board with putty) Drawing (taped to board below)

1 Setup

Draw your subject on any white paper, then tape the drawing to a board. Lay an acrylic sheet printing plate larger than the drawing over the drawing and secure it to the board with dots of poster putty. Use artist's white tape to attach the printing paper (the paper on which the final artwork will be printed) to the plate. The tape acts as a hinge.

2 Printing

After you apply ink or paint to the plate, bring the print paper down onto the plate. (The print paper stays attached to the plate throughout all printing steps to ensure proper registration.) Rub with a baren or the back of a wooden spoon to make the print. Slowly lift the printing paper off the plate. Clean the plate, apply more ink or paint, and print again—as many times as you want to on the same piece. When you're done, detach the print, then clean the plate and save it for the next time.

Tips for Working With Monotype

- Water-soluble mediums can be allowed to dry and the paper soaked in water prior to printing. This will then re-wet the ink or paint and pull it off the plate. This method works better with a press.

- If the medium is permanent, it is important to work quickly so the paint or ink does not dry before printing.

monotype

Here's an opportunity to try the monotype setup described on the previous page. Remember that with monotype, your picture will print in reverse; if you embark on a project of your own design and you want the print to be oriented the same as your reference photo, reverse your drawing before printing.

Since the ink is opaque, you can print dark over light or light over dark. Approach monotype with an experimental attitude and try different mediums for different results.

tip

Monotype is not an exact science; there will be textures and surprises. For this reason, it's a good idea to choose your subject according to the textures you hope to achieve.

materials

Water-soluble Block Printing Inks
Black, Blue, Blue Turquoise, Brown, Red, White

Brushes
Assorted small and medium rounds and flats

Surface
Stonehenge paper, black, 8" × 10" (20cm × 25cm)

Other
Acrylic sheet for printing plate, 6" × 8" (15cm × 20cm); flat palette or extra acrylic plate; small rubber brayer; white pencil; baren or wooden spoon; artist's white tape

1 Prepare the Plate and Apply the Sky Color With a Brayer

Trace the shape of the printing plate onto the black print paper with a white pencil. Do this drawing of a canyon on a 6" × 8" (15cm × 20cm) piece of white paper. (I transferred my drawing to the printing paper for the sake of clarity in these photos, but you don't have to.)

Place your drawing face up on your board and position the printing plate on top of it as shown on page 71. Place the print paper on top of the plate and line up the marked area with the plate edges. Tape one side of the paper to the printing plate with artist's white tape. Practice lowering the paper over the plate and pulling it back from the plate without removing it from the tape.

Thoroughly mix a little Blue ink, some Blue Turquoise ink and some White to get a nice medium-blue sky color. Spread the mixture on a palette or extra acrylic plate. Run the brayer through the ink mix several times to cover it. Apply the ink directly to the printing paper using the brayer, covering the upper one-third of the picture area you have marked off in white pencil. Let dry.

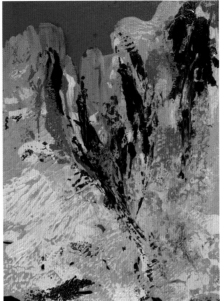

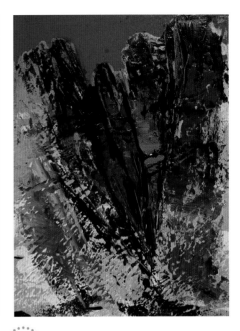

2 Print the Middle Values

Mix a little Brown ink and some White with a touch of Red to resemble Burnt Sienna. Pull your paper back to expose your printing plate. Using a brush, apply this mix to the sienna/pink areas of the plate as shown above. Mix Blue, White and a touch of Brown for the blue areas on the rocks and paint this onto the proper area of the plate. Be aware that you can use thin layers or thicker ones. There is no right or wrong, but your choice will affect the textures you get. Do not go too thick too soon.

When you are satisfied with the colors and placement, put your paper back over your plate, line it up carefully and burnish with your baren or wooden spoon to make the impression. Let these colors dry.

3 Print the Light Values

For the lightest colors, mix White with a very small amount of both Red and Brown inks. Apply this with a brush to the plate, then print. You may reprint any step more than once.

4 Print the Darks

Mix the darkest color by adding small amounts of Black to Brown or Blue. (The resulting mixture will be a livelier color than pure black would be.) Apply this mix directly to the plate with a brush to create the deep crevices of the canyon, then print.

Assess what you have done so far and adjust as you desire. At this point, I applied Brown by itself in some areas, more of the "Burnt Sienna" mix from step 2 in some areas, and more Blue. Again, print as many times as you like. If the print is still wet, adding another layer might remove some of the ink, which you may or may not want. This could create some interesting textures or leave dull areas. If you are not sure, let each layer dry before adding another.

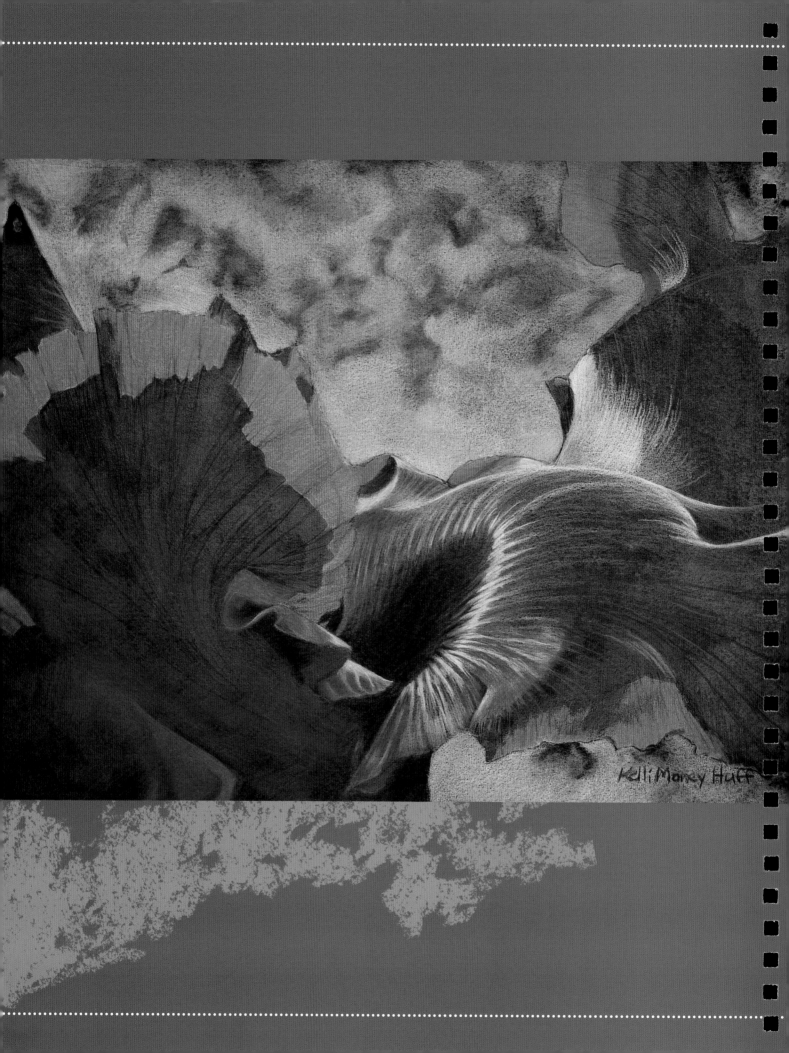

Kelli Money Huff

chapter three

surfaces

We love art supplies and have spent years playing with our materials. We try everything we can get our hands on. We cannot stress enough the importance of doing your own experiments. Your particular style and technique may not work well with our favorite papers or boards. You'll never know what surfaces work best for you until you try as many as you can.

Many well-known brands in the art materials world are touted as "the best." No one can say what is the best for you except you. By all means, use high-quality archival supplies, but do not rely on the book or the instructor who says, "Always use X brand." Products change constantly; what may have been true twenty years ago may not be true today. Pigments are discontinued, paper manufacturers change formulations, and so on. Find out as much as you can about your paints, pencils and surfaces, and continue to keep yourself abreast of changes.

Art by its very nature is experimental. Educate yourself regarding your materials and then play. Have fun!

Kristin's Iris
Watercolor and colored pencil
11" × 14¾" (28cm × 37cm)

Shown on the following pages is an assortment of papers and boards tested first with a watercolor wash and then with a layer of colored pencil. The actual size of each sample is 5" × 5" (13cm × 13cm).

There is no substitute for your own experimentation. Your results will vary with the weight of the paper, the color and the texture. There are no right or wrong surfaces to use for painting. Use what you like and what works well for your art.

Bugra Pastel Board
Finish: Laid (ribs of texture left by the screens used in manufacturing)
Wet Mediums: Very smooth wash with hardly any buckling
Colored Pencil: Nice texture for colored pencil

Bugra Pastel Paper
Finish: Laid (ribs of texture)
Wet Mediums: Very smooth; a bit of buckling in the small size of this sample. Not recommended for larger size paintings with watercolor
Colored Pencil: Laid finish shows through tonal layers

tip

When deciding what surface to use, consider the following:

1. Will you be working dry or wet? If you plan to use any wet mediums, the surface must be able to support them.

2. Do you want smooth, even tones, or texture? Smooth tones require a smooth surface. If you want texture or a loose, abstract feel, a rougher surface might be the best choice.

Velour Paper
Finish: Velvety
Wet Mediums: The soft surface soaked up the water as soon as the brush touched it. The beginning of the stroke was very wet, but it immediately turned into a dry-brush look. Can be used for interesting effects
Colored Pencil: Doesn't really show up unless you use lots of pressure

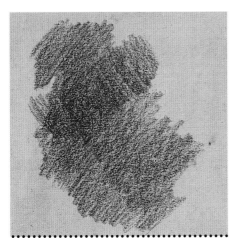

Wallis Pastel Paper
Finish: Sandpaperlike
Wet Mediums: Accepted the wash very well
Colored Pencil: Layered easily, although the rough surface ate up the pencil point quickly

Fabriano Tiziano Paper
Finish: Smooth
Wet Mediums: Wash was a little uneven; the paper buckled quite a bit but flattened out as it dried
Colored Pencil: Nice texture for colored pencil

La Carte Pastel Card
Finish: Coated with vegetable fiber
Wet Mediums: This board is not made to be worked wet. Water dissolves the surface; a second pass of the brush lifted the coating right off the board. Can be used for interesting textural effects produced by the removal of the coating
Colored Pencil: Strokes are grainy

Sabretooth Sanded Pastel Paper
Finish: Rough and uneven
Wet Mediums: This nice, heavy paper accepted watercolor very well. The wash dried fast with little buckling
Colored Pencil: A little rough for fine pencil work

Canson Mi-Teintes Paper (Smooth Side)

Finish: Smooth, fine-patterned texture

Wet Mediums: Too lightweight to handle washes except in a small size. Paper was still wavy after drying

Colored Pencil: Great texture for colored pencil; holds up well to many layers and to blending with mineral spirits

Canson Mi-Teintes Paper (Rough Side)

Finish: Mechanical, rough surface like a screen

Wet Mediums: Neither side works for wet mediums

Colored Pencil: A few colored pencil layers really bring out the texture

Colourfix Coated Pastel Paper

Finish: Has a ground applied to it; feels like a very fine-grained sandpaper

Wet Mediums: Smooth and even

Colored Pencil: Very nice texture for colored pencil work, but as with the Wallis paper, the texture eats up the pencil point

Strathmore 500 Series Pure Paper Tints

Finish: Repeated pattern, but not rough

Wet Mediums: Not made to be used wet, but held up well in a small size. Wash was a bit streaky

Colored Pencil: Plenty of tooth for colored pencil layering, but has a pattern that may show through

Degas Colour Paper
Finish: Repeated pattern
Wet Mediums: Too lightweight for water; buckled even in a small size
Colored Pencil: Useful for pencil, but a little grainy

Meridian
Finish: Similar to Canson Mi-Teintes (smooth side)
Wet Mediums: A very absorbent paper; soaked up the wash quickly, leaving some streaks
Colored Pencil: Surface is beautiful for layering

Pastelbord
Finish: Hardboard panel coated with a very fine sandpaperlike clay surface
Wet Mediums: Watercolor tends to bleed, but washes are smooth
Colored Pencil: Uses up the pencil point quickly

Canson Ingres Paper
Finish: Laid (ribs of texture)
Wet Mediums: Didn't work well with water; had trouble getting a smooth wash
Colored Pencil: Plenty of tooth to hold layers of colored pencil, but laid surface shows through

Here's an assortment of unusual surfaces tested first with a water-color wash and then with a layer of colored pencil. The actual size of each sample is 5" × 5" (13cm × 13cm).

Don't miss the fun of trying these surfaces. The plastic ones in particular make very interesting designs when the paint flows into water and sits for a time before drying.

Dura-Lar Wet Media
Composition and Finish: Smooth, clear acetate sheet
Wet Mediums: Takes watercolor well on both sides
Colored Pencil: Accepts color well on both sides. Allows some layering, but not as much as paper

Multimedia Board
Composition and Finish: A combination of cotton rag and synthetic fibers. Similar to cold-pressed watercolor paper's surface; not quite as rough
Wet Mediums: Absorbs water unevenly. With repeated passes of the brush, it was sometimes possible to improve the smoothness of washes
Colored Pencil: Nice surface for pencil; would be a good choice for subjects requiring a grainy texture with wet mediums

Acetate
Finish: Matte on one side; shiny on the other. The matte side is shown here
Wet Mediums: The matte side accepted watercolor with a light saturation of color. The shiny side accepted watercolor better
Colored Pencil: The matte side took colored pencil very well; the shiny side would not hold colored pencil at all

tip

Any time you try a new surface, document your findings. Whenever you cut a board or paper into smaller pieces, label each piece as to brand, surface texture and weight. You think you will remember, but you won't; if you're like us, you will accumulate many pieces of paper that you can't identify.

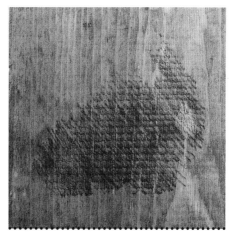

Wood

Composition and Finish: Unfinished wood, any hard wood. Can be sanded to any desired finish

Wet Mediums: Stains and emphasizes wood grain

Colored Pencil: Most pencil techniques work just fine

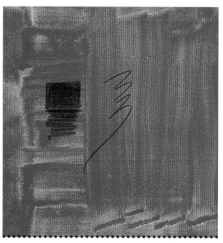

Polyart

Composition and Finish: Polyethylene with a clay coating on both sides

Wet Mediums: Can take wet or dry washes and accepts color well. When this surface is wetted first, color tends to sit on top and move around before drying, which creates some interesting effects. When the surface is not pre-wetted, color moves little and dries much faster

Colored Pencil: Accepts colored pencil well when dry, but color is less intense than on most papers

Canvas Treated With Absorbent Ground

Golden makes a product called "Absorbent Ground," which the manufacturer claims will make any gessoed surface absorbent for use with wet mediums. We applied this product (thinned with 20 percent water) to canvas in three thin coats, letting it dry between coats

Finish: Somewhat grainy

Wet Mediums: Accepted watercolor well. Washes lifted very easily

Colored Pencil: Accepted well

tip

To reduce the cost of trying many different surfaces, take advantage of free or inexpensive paper samples offered at trade shows and in art magazines and catalogs. Share and trade pieces of board and sheets of papers with artist friends who have some you've never tried.

There is a huge variety of watercolor papers to choose from. Due to space constraints, we're showing you just a small sampling; there are many other equally good brands. All these papers come in all three surfaces— hot-pressed, cold-pressed and rough—and at least two or three weights. As we've said, try as many as you can to find out what works best for you.

Fabriano Uno Watercolor Paper, 140-lb. (300gsm) Hot-Pressed
Finish: Nice and smooth
Wet Mediums: Works well for all wet mediums
Colored Pencil: Great with all pencil types

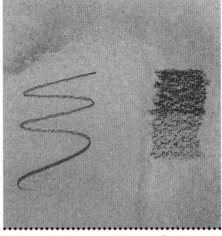

Winsor & Newton Watercolor Paper, 140-lb. (300gsm) Cold-Pressed
Finish: Semi-rough
Wet Mediums: Makes good washes
Colored Pencil: Just slightly toothy for colored pencil unless you want a little graininess

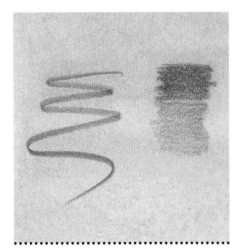

Lanaquarelle Watercolor Paper, 300-lb. (640gsm) Hot-Pressed
Finish: Soft and smooth
Wet Mediums: Makes nice washes when the paper is wet first
Colored Pencil: Great with all pencil types

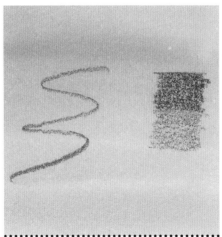

Canson 100, 300-lb. (640gsm) (Smooth Side)
Finish: Somewhere between cold-pressed and hot-pressed
Wet Mediums: A good all-around paper for wet mediums
Colored Pencil: Very good for colored pencil

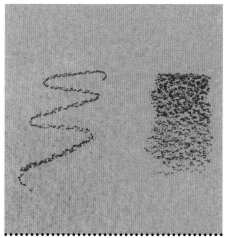

Arches Watercolor Paper, 300-lb. (640gsm) Rough
Finish: Rough
Wet Mediums: Good quality watercolor paper; readily available
Colored Pencil: This paper's roughness is not conducive to smooth pencil layers

Canson 100 Watercolor Paper, 140-lb. (300gsm) Rough (rough side)
Finish: A little smoother than other rough watercolor papers
Wet Mediums: Great for wet mediums
Colored Pencil: Not smooth enough for tonal layering with colored pencil, but would work for looser pencil techniques

printmaking paper sampler

Stonehenge Printmaking Paper
Finish: Strong with a velvety, smooth surface. Comes in several whites as well as gray and black. Smoothness makes it useful for portraits because skin tones come out even
Wet Mediums: Washes won't be smooth
Colored Pencil: One of our favorite papers for working dry with colored pencil

BFK Rives Printmaking Paper
Finish: Smooth
Wet Mediums: Like other printmaking papers, does not have as much sizing as watercolor paper, so washes will not be smooth
Colored Pencil: Good choice for a smooth colored-pencil surface

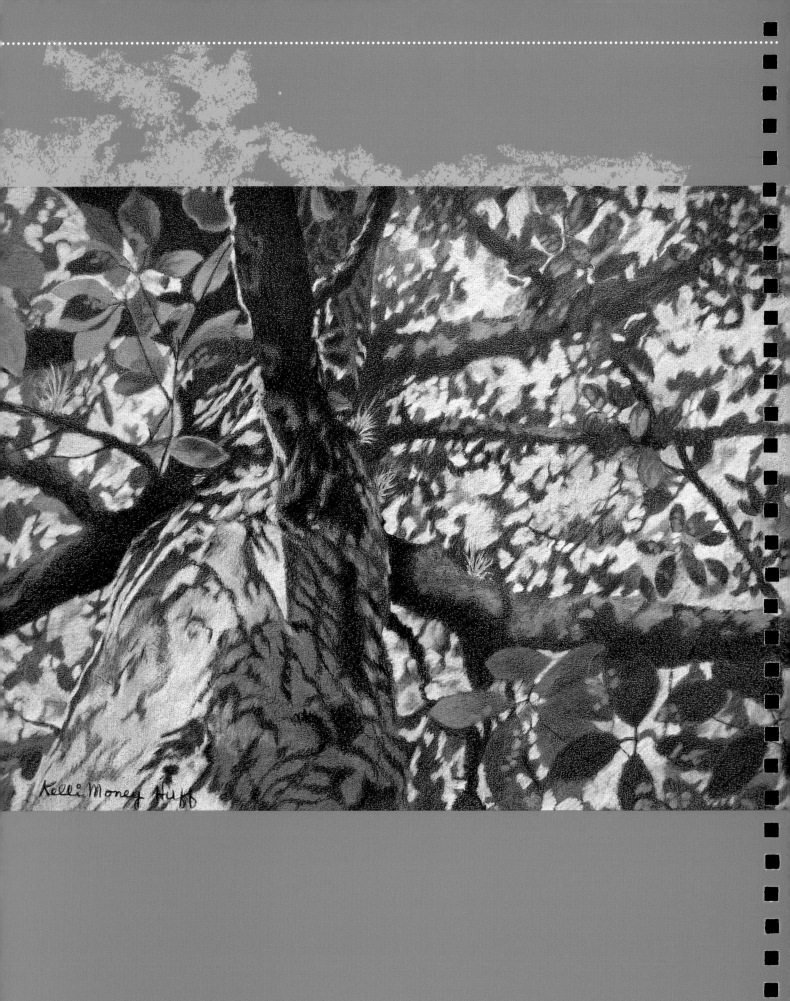
Kelli Money Huff

decision time:
choosing mediums and surfaces for paintings

Now that you've learned about mediums and surfaces, it's time to make some choices. What paint goes with what paper? And can I use pencil on that same paper? Will it be harmed by water? Are there any particular problems I should know about when I combine colored pencils with my favorite paint? These are all important considerations when making decisions about combining mediums.

Although we believe that rules in art are only guidelines, meant to be learned, but broken when appropriate, some rules must be respected. If you use your materials improperly, you may not have a permanent piece of work. Some papers and boards are designed only for dry mediums and will be damaged by wet paints. Some surfaces are not archival and will deteriorate over time. Some paints and pencils are not lightfast and will change or disappear upon exposure to light.

In this chapter we give you some specific guidelines and recommendations for putting various materials together. Use these references to help you make decisions, but, by all means, continue with your own experiments and make notes on what works for you. There are so many choices; our only regret is that we will never have enough time to try everything we want to do!

Tree View
Kelli Money Huff
Colored pencil on Canson Mi-Teintes
10½" × 13½" (27cm × 34cm)

There are two primary considerations when combining mediums:

- Compatibility: Will the mediums complement each other and work well together instead of causing problems that might damage the work?

- Stability: Will the combination stay together so that your artwork will last?

combining colored pencil with wet mediums

Colored pencil works well in a variety of techniques with most paints. It will go over most wet mediums when dry. (The exception is acrylics applied thickly—the colored pencil won't stick to the acrylic film.) When the base paint layer is wet, colored pencil won't adhere well, and the point could gouge the paper. Pencil can also be used under any of these paints as a resist. You can alternate layers of pencil and wet mediums as long as you let them dry between layers. One of the most efficient ways to combine paint and colored pencil is to use a wet medium for the first layers and then add final layers and detail with the pencils. This technique speeds the process since the wet paint/ink covers larger areas faster than pencil. The slower medium, colored pencil, is then used only for refining and detailing.

colored pencil and monotype

The ability of colored pencil to combine with most monotype techniques depends mostly on the mediums used and how thickly they are applied. Watercolor, gouache and ink do not usually present a problem, but colored pencil may not adhere to multiple layers of heavy acrylic because the surface is just too slick. Monotype done *over* colored pencil may just cover up the pencil work. Keep in mind that the surface must work for pencil as well as the paint or ink.

combining colored pencil with dry mediums

Colored pencils are very compatible with other dry mediums. Graphite combines beautifully with any type of colored pencil. You can choose to layer them in any order or just add a small touch of colored pencil to a graphite drawing. Be aware that multiple layers of graphite can get shiny and slick, and may keep colored pencil from sticking to it. Once again, a smooth surface is best for creating even tonal layers with graphite as well as colored pencil. Start with drawing papers, but be sure to try others such as printmaking papers and illustration boards. Experiment with unusual surfaces such as Dura-Lar and Yupo.

Oil pastel makes creamy, painterly washes and works beautifully with colored pencil. The pencil can be applied over oil pastel in a light layer without disturbing the pastel layer underneath if the pastel used is a harder stick and the pencil is applied with a very light touch, but softer, creamier formulas of oil pastel may be pushed aside by the hard lead of the pencil. Both hard and soft oil pastels may be scratched through if enough pressure is applied with the pencil. Keep a tissue or cloth handy to wipe the buildup of oil pastel off the end of your pencil. Oil pastel will adhere to textured surfaces, but test the paper first to see it if works for pencil as well. Pastel papers are a good choice for the combination of oil pastel and colored pencil.

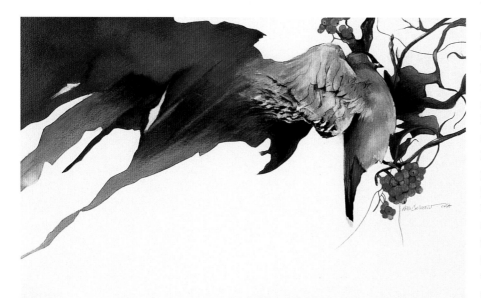

For the flowing background of this piece, Vera Curnow masked the bird with low-tack film, then randomly laid color around it with Prismacolor Art Stix. She then used a cotton pad dipped in mineral spirits to dissolve and disperse the pigment.

Waxwing Poetic
Vera Curnow
Colored pencil on cold-pressed illustration board

combining metallics with colored pencil

Leafing and Rub 'n Buff can enhance the right piece of artwork. The biggest problem is knowing when to stop. Don't get carried away; a little metallic goes a long way.

Rub 'n Buff loves texture, but make sure the surface you choose loves the colored pencil too. Use Rub 'n Buff on textured surfaces to hit just the raised hills for a hint of color. It enhances the texture beautifully. Use a variety of application tools to get different effects. Try fan brushes, liners, stencils and palette knives. Rub 'n Buff can be thinned with mineral spirits and used like paint with a brush.

Leafing is a little less versatile than Rub 'n Buff, but when applied correctly, its effect cannot be duplicated by any other method. Metal leafing adds greatly to the beauty of your artwork and can also give it an antique look. Experiment with putting colored pencil over it, or incising lines into it.

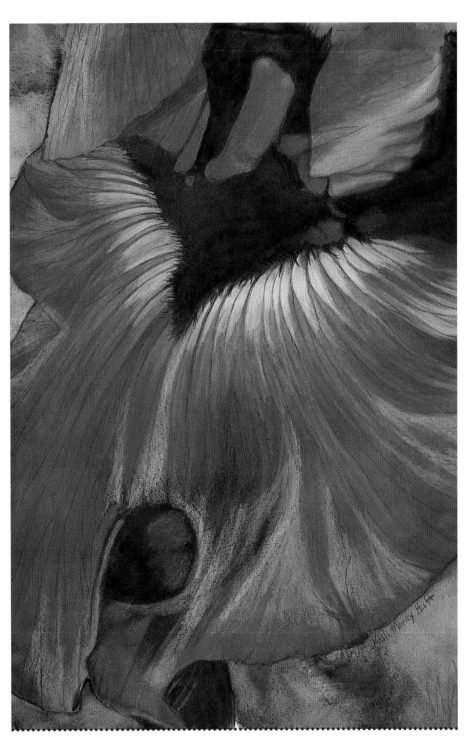

Iris Series No. 3
Kelli Money Huff
Watercolor and colored pencil on Canson 100 paper
20" × 14" (51cm × 36cm)

guide to surfaces

Each surface is listed for what it does best, but that does not mean it won't work in any other way. Experiment for yourself. This chart includes the most commonly used surfaces, but try anything and everything else you can find. That's part of the fun of mixing mediums.

Surface	Wet Mediums	Dry Mediums	Comments
Watercolor paper, hot-pressed	Excellent for all wet mediums	Excellent for all types of pencils, with or without other mediums	Beginners may have a hard time getting even washes
Watercolor paper, cold-pressed	Excellent for all wet mediums	Good for soft pastels, oil pastels and charcoal	Good choice for practicing even washes
Watercolor paper, rough	Excellent for all wet mediums	Good for soft pastels, oil pastels and charcoal	Very rough surface
Canvas	Excellent for impasto techniques in oil and acrylic	Most dry mediums do not adhere well. Accepts oil pastel	Accepts wet washes, but is not as absorbent as paper
Watercolor canvas	Excellent for watercolor; good for ink and acrylic when used in washes	Most dry mediums do not adhere well. Accepts oil pastel	Can be used for oil or acrylic if primed with gesso first
Printmaking paper	Accepts all wet mediums, but buckles more than watercolor paper	Excellent for pencils of all types, with or without other mediums. Excellent for oil pastel	Stands up well to water, but lack of adequate sizing makes smooth washes difficult
Handmade paper	Excellent, especially ones made specifically for watercolor	Can be good for soft pastels, oil pastels and charcoal	Usually too rough to work well with most pencils
Drawing paper	Most will not stand up to wet mediums	Accepts all types of pencil, soft pastel, oil pastel and charcoal	
Pastel paper	Some brands will accept wet mediums—test a sample	Accepts all types of pencil, soft pastel, oil pastel and charcoal	
Illustration board	Very good for all wet mediums	Most dry mediums will work as long as there is enough surface tooth to hold the medium	
Watercolor board, hot-pressed	Excellent for wet mediums	Too smooth for most dry mediums	When using with wet mediums, tape the edges so liquid does not seep into the cardboard backing
Watercolor board, cold-pressed	Excellent for wet mediums	Excellent for colored pencil and other dry mediums	

surface selection and planning

Try combining three, four or even more mediums. No matter how many you use, keep these very important issues in mind:

Will you be using wet mediums? If so, make sure the paper or other surface can handle being wet.

Will you be using any type of pencil? If so, the surface should have enough tooth to hold it, yet be smooth enough to get a nice, even tone. This of course does not apply if you are using a loose, scribbly technique.

Do some of your mediums need to be applied under or over other mediums? Plan the order of application carefully to avoid unwanted lifting or other damage to previous layers.

know your mediums

Make sample swatches. For every medium you own, make a sample sheet of swatches and label them with brand names and colors. This is an invaluable permanent reference.

Do a trial run. Test the mediums you want to use together on scrap paper before putting them on your good surface. Keep and label these test swatches; they are very useful for future pieces.

two roads to a painting

The two demonstrations that follow on pages 90–97 will show you that there are many ways to paint a subject, and no right or wrong ways. We took a photo of an orchid, then each of us chose our own mediums and completed a painting. At the beginning of each demonstration, we describe the process by which we chose our surfaces and mediums.

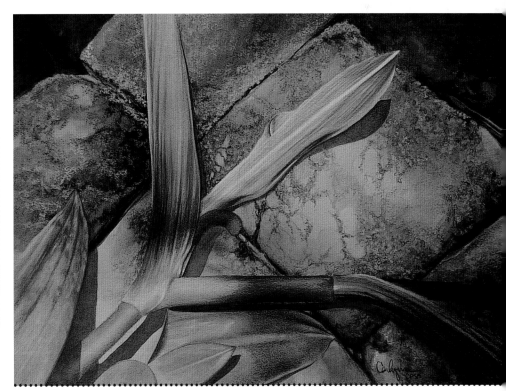

The Moss Patio
Carlynne Hershberger
Watercolor, colored pencil and oil pastel on 140-lb. (300gsm) Waterford watercolor paper
11" × 15" (28cm × 38cm)

orchid: carlynne's choices

Surface: The first time I started this piece, I used black paper, thinking the dark color would save me time on painting the background. Instead, I ended up spending a lot of time trying futilely to make the pale yellow oil pastels in the petals cover the black paper.

I noticed there was some pink in the petals, so I started over, this time on pink paper. It worked. Now, the paper color showing through the oil pastel was an advantage instead of a hindrance.

Base color for the petals: I wanted something quick and smooth. I chose oil pastel because it can be applied quickly and blended easily.

materials

Colored Pencils
Polychromos: Deep Red, Wine Red
Prismacolor: Black, Cream, Tuscan Red, White

Oil pastels
Black, Cream, Dark Green, Dark Red, Light Green, Light Red, Orange, Prussian Blue, Yellow

Surface
Canson Mi-Teintes paper, Orchid (that wasn't intentional—honest!) (smooth side)

Other
Vinyl eraser or "crayon" eraser
Paper towels or tissues

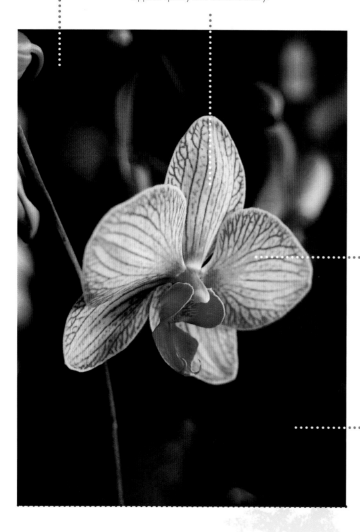

Veins in the petals: My next concern was how to create the veins. Put them in first and then paint around them? With so many veins, that would be tedious. Paint the background of the petal a solid color and then add the veins on top? That made more sense. I decided on colored pencil because I knew the hard lead would push through the soft oil pastel and create the detail I wanted. Getting such fine lines with a chunky stick of oil pastel would have been just about impossible.

Background color: Oil pastel was a good choice for the background color. The stick can cover a large area much faster than a colored pencil, and it can be blended for a smooth effect.

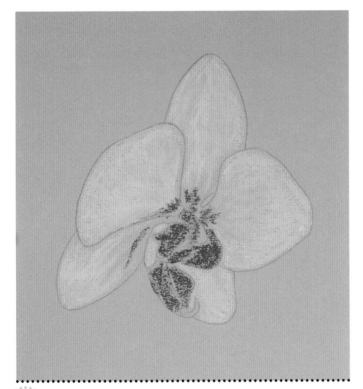

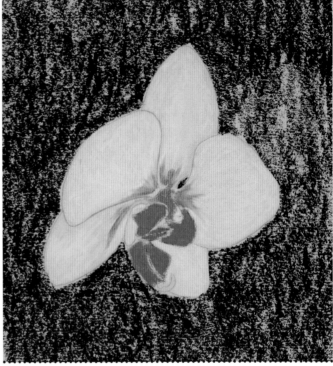

1 Draw, Then Block In Colors

Lightly draw the flower with graphite pencil. Block in color on the entire flower. Begin with a cream oil pastel and rub color on all the petals. Use a brighter yellow oil pastel to brighten the color in the center of the petals. Fill in the red at the center of the orchid with a red oil pastel. Add some of the same red at the base of each petal.

2 Work the Petals and Background

Use a vinyl eraser to smooth the layer of yellow on the petals. It's OK if the yellow is a little thin in places and lets the pink paper show through. This will enhance the flower. If, however, you don't have enough yellow oil pastel on the paper and there are areas where it just won't blend because it's too dry, go ahead and add more oil pastel and smooth again.

Work just the yellow first, then move to the red at the base of the petals. Smooth the red and then pull it out into the yellow area so it follows the same direction as the veins in the petals.

Fill in the background with a black oil pastel. Don't forget the little bit of background that peeks between the two petals on the right. Work just the yellow first, then move to the red at the base of the petals. Smooth the red and then pull it out into the yellow area so it follows the same direction as the veins in the petals.

Fill in the background with a black oil pastel. Don't forget the little bit of background that peeks between the two petals on the right.

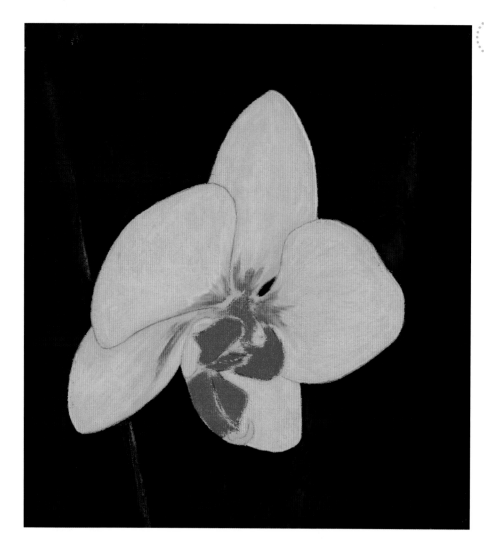

3 Finish the Background, Then Introduce Colored Pencil

Blend the background with a vinyl eraser. On top of the blended black, add some interest by introducing some other oil pastel colors such as orange, red, Prussian Blue and dark green. Use a lighter green to add the stem on the left. You can blend some of this into the background in some areas and leave some textured for contrast in others. These colors won't be bright, but rather subdued since there's black underneath.

Use a Black colored pencil to clean up the edges of the background against the flower petals. On the edges of the petals, use White and Cream colored pencils. Keep a tissue or paper towel in your other hand for cleaning the pencil point. As it pushes the oil pastel out of the way, it creates crumbs of pastel. If these fall on the painting, gently blow them away or lightly wipe them off with a tissue. Be careful not to press too hard when you do this so you don't smear the work.

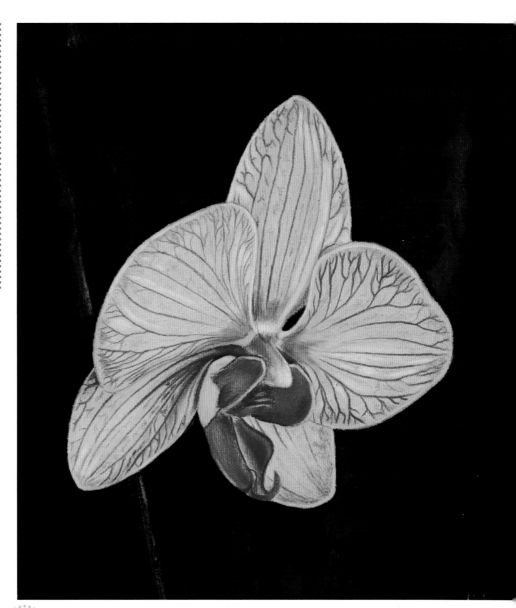

4 Finish

Draw the veins on the petals with colored pencil, starting with the Deep Red. Be sure you have a sharp point on the pencil; a sharper point means a finer line. Don't worry if you get a line out of place. It's like magic! You can erase it with the cream oil pastel and do it again. For the veins that are very dark, go over them again with the Wine Red. Between the veins you can see bits of light red color. With very light pressure, color these with Deep Red.

Using all three red pencils, model the red part in the center of the flower. If you use very light pressure you can actually put colored pencil on top of oil pastel. Do this with the Tuscan Red to deepen values. Now notice the light areas on the petals. Use White pencil with heavy pressure to put some highlights on the edges of the petals and between the veins where the petal is lighter. Give the background a little more color by adding more Prussian Blue oil pastel.

Surface: My favorite papers are Lanaquarelle hot-pressed watercolor paper and Canson 100. Both work very well for watercolor, acrylic and colored pencils, the three mediums I planned to use. Of course, both these papers are made specifically for wet mediums, but they also have smooth surfaces which are ideal for pencil. I ultimately decided on the smoother side of the Canson paper because the surface is less slick and crisp than the Lanaquarelle, which makes it a little easier to get fast, even washes. I knew I would want to keep the layers of watercolor to a minimum because Canson 100 can tend to get fuzzy after being reworked several times.

Base color for the petals: My favorite medium to use with colored pencil is watercolor, and I thought that would work very well under the pencil for the lighter colors in the petals.

materials

Colored Pencils
Prismacolor: Dahlia Purple, Dark Green, Hot Pink, Indigo, Limepeel, Mulberry, Peacock Green, Process Red, Tuscan Red, White
Polychromos: Lemon Yellow

Paints
Golden Fluid Acrylic: Hansa Yellow Opaque, Jenkins Green, Quinacridone Violet
Da Vinci Watercolor: Indigo

Brushes
Assorted medium-sized round and flat synthetic brushes

Surface
Canson 100 paper (smooth side)

Other
Graphite pencil, sponge, kneaded eraser, paper towels; light box or bright window

Veins in the petals: When we chose the photo, my first thought was that the vein lines were perfect for colored pencil and I knew that there were several colors that would work. I also toyed with the idea of incising lines for the veins and then letting watercolor fill them. I would then use colored pencil for surrounding colors. However, I decided that was making it more complicated than it needed to be, so I went back to the original plan of using colored pencil for the lines.

Background color: With the background being very dark, I wanted a medium that would not lift if I added more wet paint on top of or around it, so I chose acrylic to get the depth of value as well as permanence. I also knew that if I put acrylic down first with watercolor on top, I could lift the watercolor in select areas to let the acrylic color come through.

1 Start the Background

Draw the outlines of the main shapes onto your paper. Do not bother with the vein lines of the flower at this point. Prepare a pale wash of Hansa Yellow acrylic. Wet the entire back and front of your paper and then wash in the yellow over all. Don't worry about getting it even; instead pay attention to the places that have more yellow and add more paint to those areas. Let it dry completely. Mix a little Jenkins Green acrylic with water. Wet the back of your paper. On the front, wet everything but the flower, including the background and the stem. Paint in the green, deliberately making it uneven in the background.

2 Begin the Flower and Stem

Mix Quinacridone Violet acrylic with just a little water for the red-violet color in the center of the flower. On the front of the paper, wet just the center violet area of flower. Do not use an excessive amount of water. If you have puddles, remove them with a paper towel. The paper should be damp but not soaked. When the paper is ready, drop in the paint mix and cover the wet area. While the paint is still wet, use your brush to wet the flower petals with plain water right up to the violet center. Starting at the center, drop in the Quinacridone Violet acrylic and let the paint flow into the petals for just a little way.

While you are waiting for this to dry, draw in the darker shadow side of the flower stem with a Dark Green colored pencil. With a Limepeel colored pencil, draw in the opposite, lighter side of the stem.

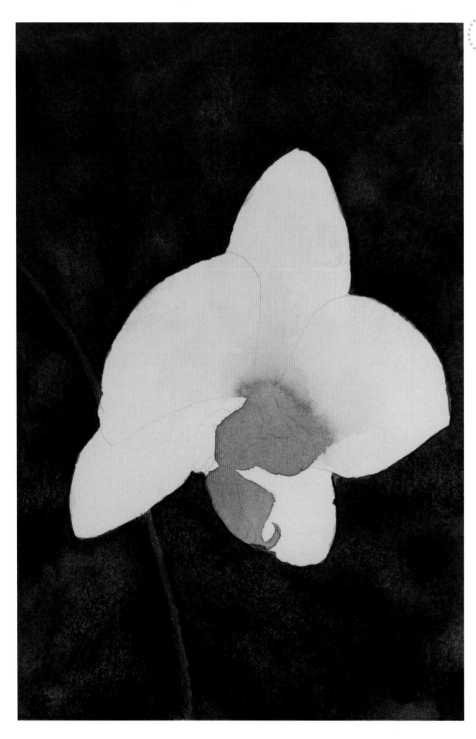

3 Deepen the Colors

Use Indigo watercolor to make a fairly dark mix of paint. Wet the back of the paper; on the front, wet the entire background. Wash in the Indigo watercolor and let it dry. Go back into the background and lift some of the Indigo in random areas by rubbing with a clean damp brush. Let dry.

Go over the stem again with Limepeel and Dark Green pencils, then go over both colors with Peacock Green. Add Indigo colored pencil to the darker side of the stem and put another layer of Peacock Green over the entire stem. In the background add pencil layers of Dahlia Purple and Indigo in random areas, then soften by lifting with a kneaded eraser.

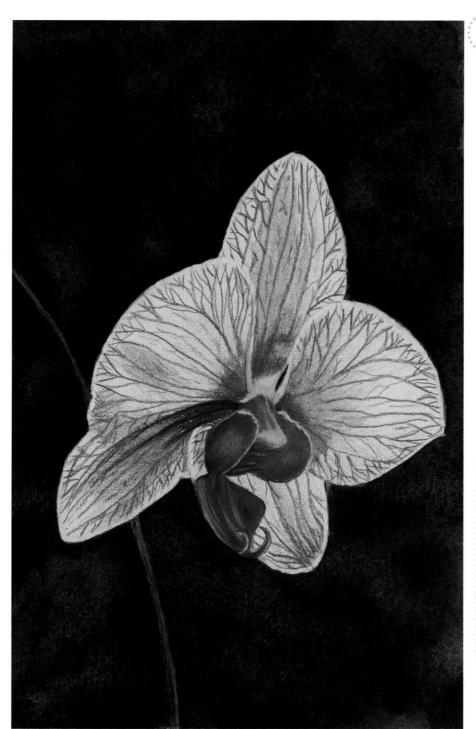

4 Detail With Colored Pencil

Using a light box or a bright window, put the drawing under your artwork so you can see the lines through the paper. With a Process Red colored pencil, transfer the veins and other details of the flower. Go over the vein lines with Mulberry. Put layers of Hot Pink, Mulberry and Process Red at the base of the petals where they are pink. Use Mulberry over the entire pink center of the flower. Along the outer edge of the flower petals, use a White pencil, and do the same along the edges of the center of the flower. Cover the petals with Lemon Yellow between the veins. In the areas of the petals that have a green tint, use Limepeel. Tuscan Red will work in the darker parts of the center of the flower. Use a touch of Indigo colored pencil in the very darkest places. To finish up, put a little White on the right side of the stem. Also use White to tone down any areas of pink that need softening or smoothing out.

artist's comments

I really love the way watercolor paint floats into the wet areas, and I used the acrylic the same way. For details, I prefer a pencil point instead of a brush.

chapter five

painting projects

You've learned how to select and apply various mediums, how to choose surfaces, and how to combine them. Now, it's time to practice your skills with full-length painting projects. In this chapter, we have included step-by-step instructions for a variety of subjects using a variety of mediums.

Some people think that an artist must be predictable, with a consistent medium and subject matter, to be considered a "serious" artist. Although we each started out working in one medium, we've found that we enjoy experimenting too much to stick to just one. We feel that the definition of art is expressing yourself by any means available. The means and the emotions evolve over an artist's lifetime.

The truth is that style comes through no matter what medium the artist uses. Pablo Picasso is a perfect example of this. In the beginning, his drawings were curvilinear, soft and realistic. However, his career was long; he lived to be a very old man. Imagine how bored he would have been if his art hadn't changed through the years. If you are working with the same medium and the same subject over and over again, you may not be growing as an artist. It might be time to try something new and perhaps to combine mediums.

It is important to note that some exhibitions require that only one medium be used. The Colored Pencil Society of America requires 100 percent colored pencil in their annual exhibition; the watercolor societies require watermedia, and so on. However, there are many magazine competitions, mixed-media societies and layerist's groups, such as the Society of Layerists in Multi-Media, that welcome all mediums and celebrate combining them.

The projects in this chapter provide excellent practice to help you get used to mixing your materials. After these, we hope you will make up your own combinations. Remember that art is not just about the finished product. Enjoy the process. Have fun!

Payne's Prairie Floater
Carlynne Hershberger
Watercolor and colored pencil on 300-lb.
(640gsm) hot-pressed watercolor paper
7" × 10½" (18cm × 27cm)

watercolor and colored pencil

We did this project together! Kelli did steps 1 and 2, and Carlynne did steps 3 through 6.

You will notice that we have specified Winsor & Newton Payne's Gray. It is bluer than other brands and is the best color for this project.

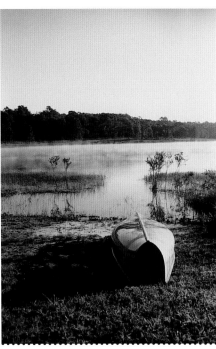

Reference Photo

materials

Watercolor Paints
Burnt Sienna, Cobalt Blue, Gamboge
Winsor & Newton: Payne's Gray

Colored Pencils
Polychromos: Gold Ochre, Walnut Brown
Prismacolor: Blue Slate, Cream, Dark Green, Goldenrod, Indigo Blue, Jasmine, Limepeel, Sienna Brown, Sunburst Yellow, Terra Cotta, Tuscan Red, White

Brushes
Large flat wash brush, assorted small and medium rounds

Surface
Lanaquarelle hot-pressed watercolor paper, 300-lb. (640gsm), 10" × 8" (25cm × 20cm)

Other
Graphite pencil, paper towels, sponge

Line Drawing

1 Do the Drawing, Then Paint the Base Washes

Lightly draw the composition on your paper. Mix a light value of Gamboge watercolor. Wet the back and front of your paper completely. Wash in the Gamboge and, before it dries, remove some color from the white areas with a clean, damp brush or a paper towel. Let dry.

Mix a wash of Cobalt Blue just a little darker in value than the Gamboge. Once again, wet the back of the paper. On the front, wet the sky from the top down just through the bottom of the water areas, right over the tree line. Wash in the Cobalt Blue and smooth it out. Then, while the blue is still wet, remove color from the lighter areas and grassy places as shown here. Let everything dry.

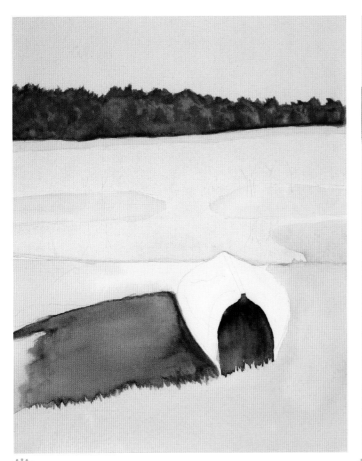

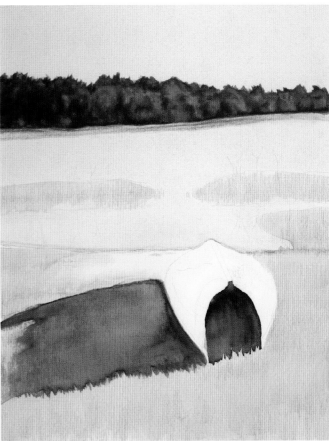

2 Paint the Grasses, Trees and Shadows

Wet the grassy areas in the foreground and wash in a medium value of Burnt Sienna. While this is still wet, you can work on the tree line. Use Cobalt Blue and Gamboge to mix a medium green, and brush this into tree areas. While this is still slightly wet, brush in more green in areas of the trees that are the darkest, especially near the bottom. Use a scumbling stroke; there's no need to be too careful. Remove a little color with a paper towel or a brush, particularly near the treetops.

When the Burnt Sienna wash is dry, wet the end of the canoe and the canoe's shadow. Paint in a wash of Payne's Gray, making the shadow a little lighter in value than the end of the canoe. Also, be sure to shape the bottom of the shadow as shown in the drawing on the facing page to make it easier to draw in the grass shapes later.

3 Enhance Shadow Areas With Colored Pencil

The texture of the washes you applied in step 2 suggests lights and darks; use these textures as your guide for this step. Use Dark Green and Tuscan Red colored pencils for the shadows in the trees to the left. It's OK to use heavy pressure here; also, try using circular or scumbling strokes to enhance the texture of the trees. For the light side of the trees, scumble Goldenrod and Limepeel. For the ground in front of the trees, layer Goldenrod and a little Dark Green. Now, moving down to the land in the middle and foreground, color a layer of Gold Ochre over all. Use loose vertical strokes; this is the grassy area. On top of that layer, add Goldenrod and Jasmine with the same type of stroke.

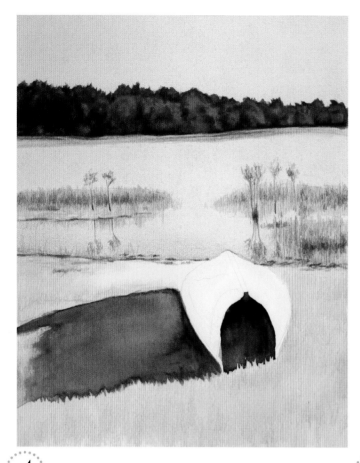

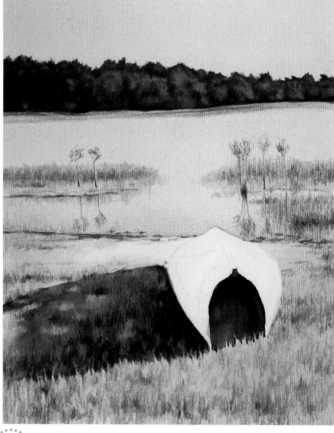

4 Add Colored Pencil to the Water and Vegetation

With Blue Slate and a sharp point, color *very* light layers on the foreground water. The water should be darkest near the shore and lighter as it moves toward the background.

On the bits of grass out in the water, use Goldenrod, Limepeel, Dark Green and Sienna Brown with vertical strokes. Follow the pattern of light and dark in the reference photo on page 100. For the grasses' reflections, bring some Sienna Brown strokes down into the water. Also define the small trees with Sienna Brown. Use Limepeel and Dark Green for the leaves on top. Again, bring the reflections down into the water with the same colors. For darker values at the bases of the grassy clumps, add Walnut Brown. Use the same brown to define the shoreline.

5 Work the Foreground Grasses With Colored Pencil

For this step, keep your pencil strokes quick and loose. Fast, random, vertical strokes work best. You don't want to end up with stripes or a polka-dotted ground that looks unnatural.

Over the base layer of Goldenrod colored pencil on top of the watercolor wash, add Sienna Brown, Terra Cotta and Walnut Brown. Also add a touch of Limepeel for a bit of green on the right side. Don't forget to bring some pencil into the canoe's shadow. As you work back toward the water, make the strokes shorter; the farther away the grass is, the shorter the blades should look. Darken the shadow of the canoe a little by adding some Indigo Blue and go over that with Sienna Brown. For some added highlights overall, add a few strokes in Cream and White.

6 Finish the Canoe With Colored Pencil

Use Blue Slate pencil on the canoe to map out the reflection pattern. Add Indigo Blue to the darkest areas of the reflections on top of the canoe. On the shadow side, use Blue Slate, Indigo Blue and Sunburst Yellow to define the shapes of the reflections. Those dark blue areas are very dark, so once you have the pattern mapped out, don't be afraid to use some pressure with the Indigo Blue.

Between the darker reflections on the top of the canoe, there's some soft blue. Notice that the left side is darker than the right. With a sharp point, lightly layer Blue Slate from the left to the right in a graduated tone, getting lighter as you approach the top center line. On the right side, let the white of the paper be the highlight. Add some Blue Slate at the top near the center. Create the reflection of the grass at the lower right side of the canoe with Goldenrod and Sienna Brown.

If there are any areas of dark watercolor with ragged edges, use Indigo Blue to sharpen them. Smooth, clean edges will give the illusion of shine. On the dark end of the canoe that's facing you, color a layer of Indigo Blue. Use a very sharp point to clean up any rough edges.

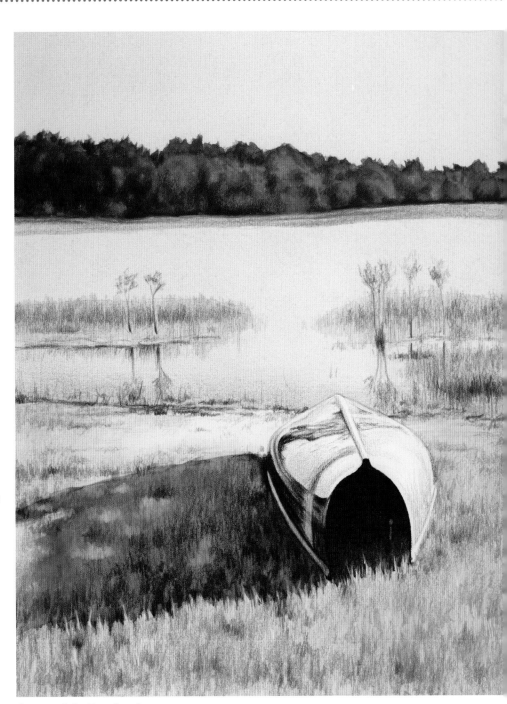

Canoe at Lake Tomahawk
Kelli Money Huff and Carlynne Hershberger
Watercolor and colored pencils on hot-pressed watercolor paper
9½" × 7½" (24cm × 19cm)

watercolor, colored pencil and gouache

With just a handful of colors you can mix a beautiful array of grays. The reference photo for this project contains a variety of blues, grays and browns. When the instructions say to mix Prussian Blue or Neutral Tint with Burnt Sienna, don't worry about exact proportions. Mix colors that please your eye.

Remember, adding more Prussian Blue will make a cooler gray, and adding more Burnt Sienna will make a warmer gray or even brown. Keep a paper swatch close by so you can test your colors before painting.

materials

Watercolor Paints
Da Vinci: Burnt Sienna, Payne's Gray, Prussian Blue, Raw Sienna, Sepia
MaimeriBlu: Neutral Tint, Quinacridone Gold

Colored Pencils
Prismacolor: Apple Green, Beige Sienna, Burnt Ochre, Celadon Green, Cream, Dark Green, Dark Umber, Ginger Root, Indigo Blue, Mineral Orange, Peach Beige, Powder Blue, Putty Beige, Rosy Beige, Slate Grey, Terra Cotta, White

Gouache
Holbein: Burnt Sienna, Burnt Umber, Naples Yellow, White

Brushes
Assorted round watercolor brushes, including small rounds such as 1, 0 or smaller

Surface
Canson 100, 300-lb. (640gsm), 15"× 22" (38cm × 56cm) (use smooth side)

Other
Paper towels, extra palette or small plate, pump spray bottle

Reference Photo

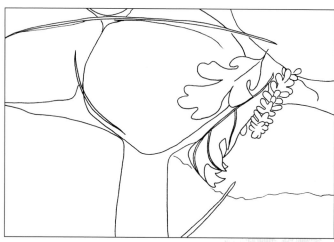

Line Drawing

1 Start With a Blue-Gray Watercolor Wash

Draw the composition lightly on your paper. Mix a blue-gray from Burnt Sienna and Prussian Blue. Paint this on all the stones except the two at the upper left, taking care to paint around the three large pieces of straw (these should be left unpainted until step 7). On the lower left stone, don't cover the entire thing; dab with the brush and leave some gaps where the paper shows through. You might even use a paper towel on the stone while the paint is wet to add a little texture.

2 Add More Watercolor Washes

Add a small amount of Prussian Blue to a puddle of Burnt Sienna to make a warm gray, almost brown. Paint this wash over the remaining stones and on top of the blue-gray washes on the two bottom stones. With Quinacridone Gold, paint the two larger leaves. Add a bit of Prussian Blue to the remaining Quinacridone Gold mix and paint this green on the smaller leaves. If the first wash leans too much to the yellow, just add a little more blue and go over it again.

Paint Sepia on the dark areas between the rocks. Notice that some stones have hard edges and some soft. Where they are soft, pull the Sepia over the edge of the stone with a clean wet brush while the Sepia is still wet.

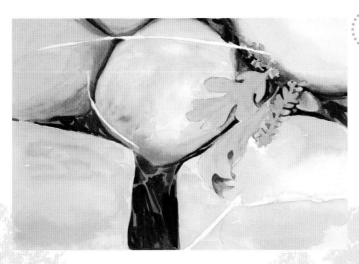

3 Strengthen the Values With Watercolor

Paint a second layer of Sepia watercolor in the spaces between the rocks with loose strokes, letting the first layer show through in some areas. The variations in the values will give the area depth. Keep this loose; you're not painting around the individual tiny bits of grass or weeds.

For the round stone in the middle, mix some Sepia with Prussian Blue and wash this mixture along the bottom to darken it. To keep the edges soft, clean your brush and use the wet brush to pull the color up and fade it out.

Strengthen the leaves with a second layer of Quinacridone Gold. After this is dry, mix a little Sepia with the gold and paint the dark folded area inside the lower leaf. Darken the sides of the brown stones on the left with Sepia.

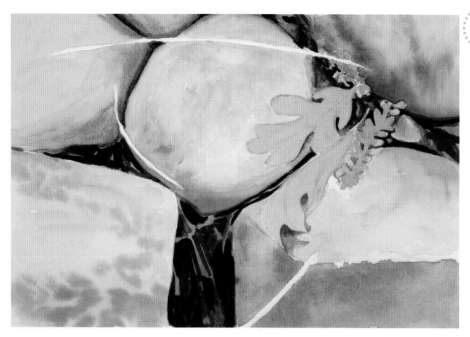

4 Add Watercolor to the Rocks

Make a strong mixture of Prussian Blue and Payne's Gray watercolor on your palette. With clean water, wet the areas on the rocks where you want the darker color to go. Drop color onto the wet areas and let the color move on its own. Sometimes you get far better results by getting out of the way and letting the paint do its thing. Don't paint it solid; just drop color in here and there. Drop more where the stone is darker.

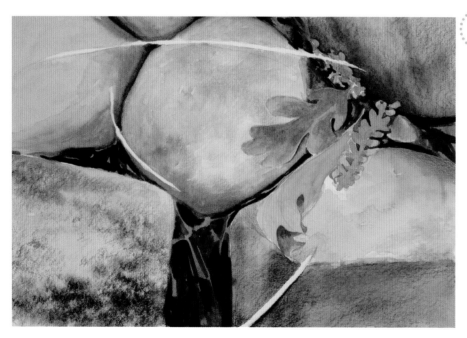

5 Detail the Leaves and Rocks

Darken the top leaf with a wash of Burnt Sienna watercolor. Leave the lighter gold color at the tips of the leaf.

Now it's time for colored pencils. Be absolutely sure that the paper is dry first so you don't gouge the paper. Start with Indigo Blue at the upper right corner. Gripping the pencil in your palm, drag the side of the lead over the paper. Skim across the surface lightly for a nice grainy texture. Do the same on the bottom portion of the lower right stone and at the lower left. The rock on the left has more concentrated color, so after skimming the surface with the side of the Indigo Blue lead, use the point to fill in more solid color where needed.

On top of these blue layers on the rocks, add some Rosy Beige and Beige Sienna. The center stone is smooth, so use the point with light pressure. Use an assortment of colors on the stones, such as Powder Blue, Slate Grey, Rosy Beige, Ginger Root and Indigo Blue. Where there is rough texture, use the side of the lead; where the stones are smooth, use the point with very light pressure.

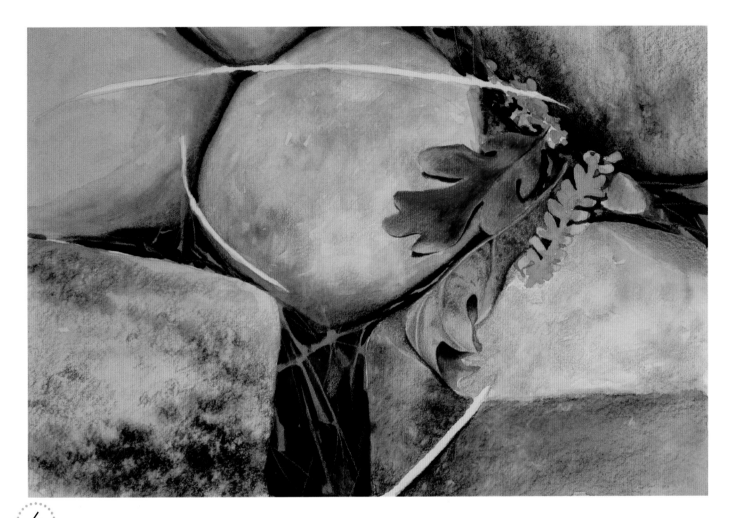

6 Continue With Colored Pencils

The two leaves need more color. Begin with Terra Cotta to deepen color on the top leaf. Use Dark Umber for the dark spots and the shadow under the leaf.

Now build color over all the leaf with Burnt Ochre, Mineral Orange, Terra Cotta, Dark Umber and Cream. On the bottom leaf, use Burnt Ochre to deepen the color and Dark Umber for the dark spots. On the left side of the same leaf, use Beige Sienna for the dark areas around the veins.

The top surface of the stone on the right needs more texture, so scumble on a little Beige Sienna. Use light pressure; you don't want it to get too dark. On all the stone areas that are blue, scumble some White with heavy pressure to bring out the lighter flecks.

Use Ginger Root and Peach Beige to break up the dark spaces between the rocks and indicate where the little bits of grasses are (you'll paint the grasses with gouache in the next step). Use Indigo Blue to color the darkest areas between the lines.

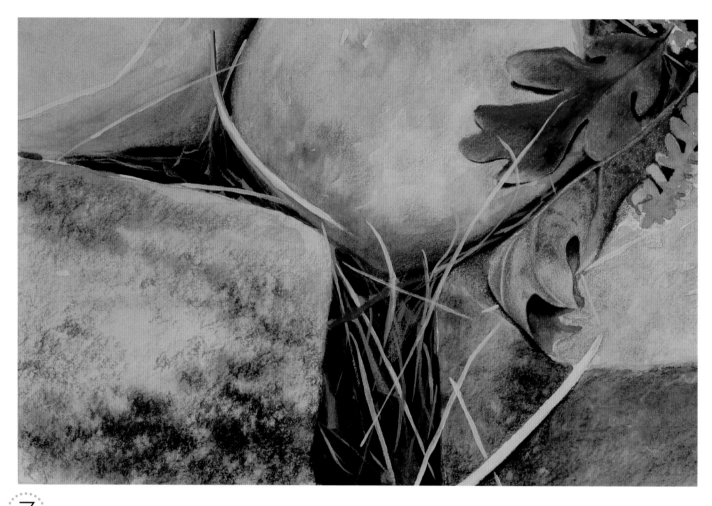

7 Move On to Gouache

On a small plate or palette, put a small dab of each of the four gouache colors. Give these a spray of water. The gouache has to be thinned down quite a bit in order to paint fine lines.

Mix the four gouache colors in varying degrees of tone and value. Some darker mixtures may be mostly Burnt Umber and Burnt Sienna with just a touch of Naples Yellow or White; these will be used for the bits of straw that are down in the shadows. For the lighter straw pieces on top, use more White and Naples Yellow in the mixture.

Paint the straw with a fine round brush such as size 1, 0 or even smaller. Use a light-value mix for the three larger pieces of straw that were left unpainted in the earlier steps. Remember that your mixes need to be thin in order to paint thin lines.

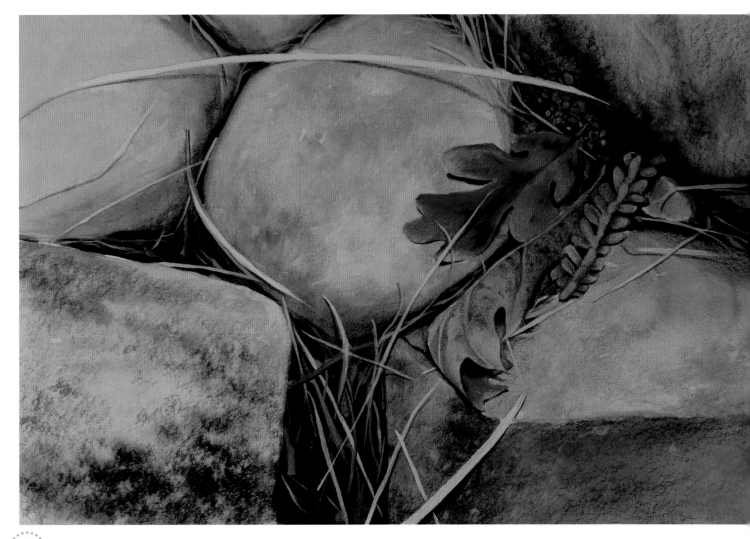

8 Finish With Colored Pencil

Use an assortment of beiges, Cream, White, Burnt Ochre and Dark Umber pencils to add more color to the straw and the shadows under it. Be sure to look for the drop shadow cast by the largest piece of straw onto the top leaf and across the center stone. This is what really brings the work to life and gives it dimension.

Use lighter colored pencils to add detail in the dark areas between the painted straw pieces. Look around now for finishing touches: add spots to leaves; clean up edges.

To finish, add Apple Green pencil to the leaves on the upper right and Celadon Green to the leaves below. Use Dark Green to darken the values and define edges on both sets of green leaves. If the texture of the Dark Green looks too rough because of the paper texture, put a layer of Celadon Green on top to smooth it out. Fill in any gaps left between the leaves with Dark Umber.

Autumn Leaves
Carlynne Hershberger
Colored pencil, watercolor and gouache on Canson
100 paper (smooth side)
14½"× 21½" (37cm × 55cm)

fluid acrylics with colored pencil

The combination of mediums in this project is probably my favorite at the moment. I love the way fluid acrylic flows like watercolor and yet stays permanent. It's fun and fairly easy to create the textures in the stone wall. As you can see, I removed the people from the composition to focus attention on the bird.

materials

Acrylic Paints
Golden Fluid Acrylics: Raw Umber, Burnt Sienna, Anthraquinone Blue, Raw Sienna, Payne's Gray, White

Colored Pencils
Polychromos: Aquamarine, Bistre, Burnt Sienna, Dark Indigo, Dark Sepia, Van Dyck Brown, White
Prismacolor: Beige, Beige Sienna, Black Cherry, Clay Rose, Copenhagen Blue, Dark Umber, French Grey 10%, 20% and 50%, Light Cerulean Blue, Light Peach, Putty Beige, Rosy Beige, Sienna Brown, True Blue, Warm Grey 70%, White; colorless blender

Brushes
Assorted synthetic rounds and flats

Surface
Canson 100 watercolor paper (smooth side), 14" × 10" (36cm × 25cm)

Other
Graphite pencil, masking fluid and old brush, drafting tape or artist's white tape, heavy paper or cardboard, disposable plate, old toothbrush, paper towels, kneaded eraser, electric eraser

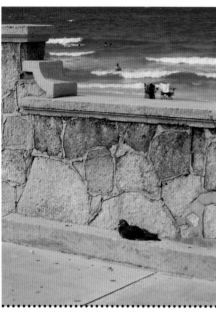

Reference Photo

Line Drawing

1 Apply the First Wash, Then Draw

Before drawing, apply your first wash of color. Mix Raw Umber fluid acrylic with enough water to make a light- to medium-value wash. Wet the back and front of the paper. Using the photo as a guide, wash in the Raw Umber mix, placing more paint where the rock wall is darker and less where the value is lighter. The washes don't have to be perfect, as there are many layers yet to come.

After the paper is completely dry, draw the subject on top of the wash with graphite pencil, making sure the lines are clean and not too dark.

2 Wash In Sienna and Mask the Waves

Mix a light wash of Burnt Sienna fluid acrylic. Wet the back of your paper with plain water. On the front, wet only the wall and sidewalk with plain water. Wash in Burnt Sienna in those areas. While the Burnt Sienna is drying, mask the white waves in the water area using a small (no. 1 or 2) round masking brush. Let everything dry.

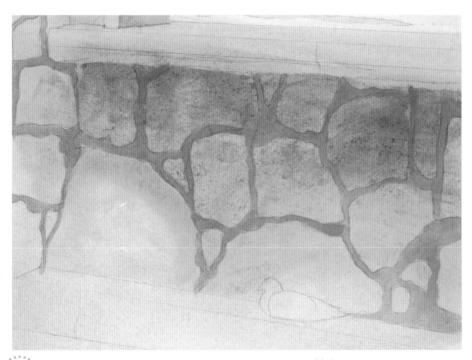

3 Define the Stones With Acrylic

Paint the grout around the stones with a mix of Burnt Sienna, Raw Umber and White fluid acrylic. Do not be concerned about getting the color perfectly even. Let this dry.

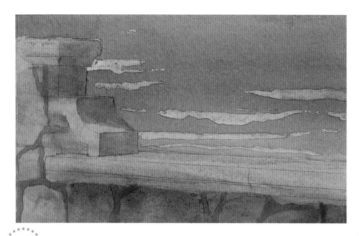

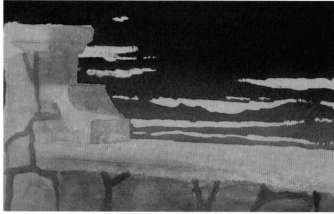

4. Paint the First Wash on the Water

Next, mask the top of the wall. Let it dry completely, then work on the water. Mix Anthraquinone Blue fluid acrylic with a little bit of water to a fairly strong value. Wet the area of water and wash this right over the masked waves and the entire top of the piece.

5. Darken the Water

It is very likely that you will need to do a second wash of Anthraquinone Blue to get the water just the right color, but remember to let it dry between layers. When this is completely dry, remove the mask on the waves and the top of the wall. The masking will remove a little color, but don't be concerned; we will be putting more layers on.

6. Mask and Spatter

Apply masking fluid to the grout around the rocks in the wall. Also mask the bird in the foreground. Let the mask dry. Tape two pieces of heavy paper or cardboard to the top and bottom of the art as shown, so that you can spatter the stone area only. Place a few drops each of Raw Umber, White and Burnt Sienna (do not mix them together) on one disposable plate. Use a little less Burnt Sienna than the other two colors. Wet an old toothbrush, then rub it into the colors. Do not be concerned about whether or not the colors mix together.

Hold the teeth of the brush facing down toward the paper mask. Drag the handle of a small paintbrush across the bristles of the toothbrush. Experiment with the angle and closeness of the brush in relation to the paper to get small spots. Get more paint if needed and spatter your artwork in the manner that works for you. If any of the spots are too large or the color is too white or dark, touch them lightly with a wet brush or paper towel to soften or remove them. Let this dry, then decide if the stones need more spatters. Remember, you will be using colored pencil on this piece, so you'll be able to add a few more spots later also.

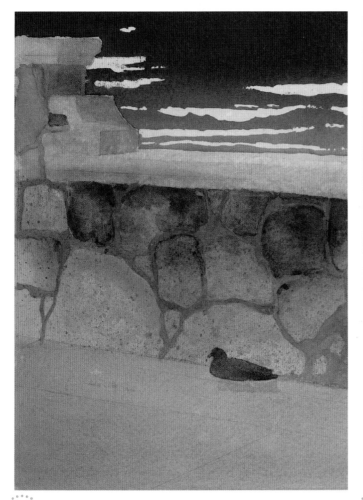

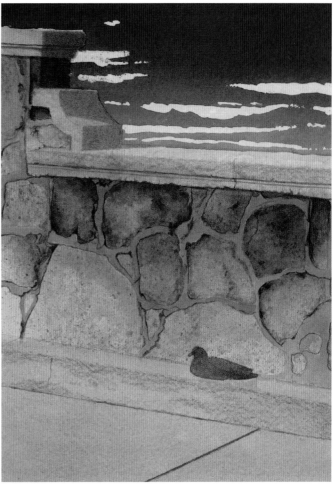

7 Add Middle and Dark Values to the Wall

Remove the paper mask by gently and slowly removing the tape so as not to tear your paper. Mix a light wash of Burnt Sienna and Raw Sienna fluid acrylics and wash it over the top of the wall where the masking fluid used earlier may have removed color. Remove the masking from the bird and the grout. Using Raw Umber and Payne's Gray, mix a medium-value wash and use a small round brush to paint in the bird. Change to a larger round to put the darker values in the stones. Dab, drag and drop color on the dark areas of rocks, using the photo on page 110 as a guide. Do not be fussy; you want texture, but try to avoid too many hard edges. Wet the bottom area below the wall and wash in the same mix, only paler.

8 Detail the Wall With Acrylics, Then Colored Pencil

Using a mix of Raw Sienna and Burnt Sienna fluid acrylics, paint over areas of the top of the wall where masking fluid used earlier may have removed color. When this is dry, mix a pale wash of Raw Umber to go over only the front edge of the top of the wall. Do the same thing with the front edge of the bottom of the wall, just below where the bird is sitting.

Using Dark Sepia, Van Dyck Brown and Dark Indigo colored pencils, draw the dark crack lines around the grout. Work your way over all the grout in the entire wall. Use Dark Sepia and a little Dark Indigo in the darkest areas and Van Dyck Brown in lighter and warmer areas. Do not make the lines all match: Some are thinner, some wider, some are darker and some lighter. Use these same pencils to draw cracks and crevices in the top edge of the wall. Again using the same colors, fill in some of the darker shapes in the stones themselves, dragging the side of the lead over the paper. Soften with a kneaded eraser where necessary.

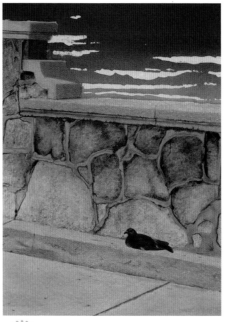

10 Finish the Stonework and Bird With Colored Pencil

With both White colored pencils, work along the edge of the wall and sidewalk where there are chips missing in the cement. Notice that the Polychromos White makes a weaker mark than the Prismacolor White, so use each where appropriate. Using a combination of both whites, Clay Rose, Rosy Beige, Light Peach and the French Greys 10% and 20%, scumble in the lighter textures on the rocks. Use the photo on page 110 as a guide to see where the colors are, and layer them to get a more realistic look. Sometimes you can use the side of your pencil point for more texture; just don't overdo this technique.

Add deeper values and textures with Light and Dark Umber and Burnt Sienna, Sienna Brown and Beige Sienna. Use your kneaded eraser to soften any layers that are too dark. Add a layer of Beige Sienna and French Grey 50% on the front edge of the curb. Put in the light areas of the bird with French Grey 50%, such as around the eyes and beak. Use the Black Cherry and Warm Grey 70% to color in the eye and dark body of the bird. Take the Warm Grey 70% layer right over the top of the French Grey 50% on the bird's light colors to blend them. If it looks grainy, use another layer of Warm Grey 70% and heavier pressure to blend and finish.

9 Work In More Colored Pencil

Put a layer of Rosy Beige pencil on all lighter areas of the top of the wall and Clay Rose on the darker areas. Use the same Rosy Beige on the grout. Add layers of Clay Rose and Bistre in the darker shapes in the grout. Use Putty Beige for the lightest parts of the grout. With a colorless blender pencil and some muscle, smooth out all the colors on the grout. Add Dark Umber to the cracks around the grout and any deep lines and dark shapes on the grout itself.

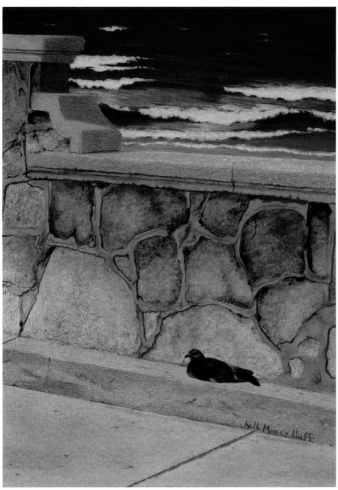

Detail: Colored Pencil Procedure for Waves

Do the following for each wave, working one wave at a time:

1. Go over the upper edge of the white part of the wave with an uneven layer of Light Cerulean Blue—just touches of it here and there.

2. Remove areas of blue with a battery-powered eraser to simulate the look of the waves.

3. Soften the hard edge on the bottom of each wave by coloring the lower part of each wave with Prismacolor White and lots of pressure, bringing it down right over the hard edge onto the blue of the water.

4. Bring the white up and over the blue that you put at the top of each wave, again using pressure.

5. Burnish the wave all over with Prismacolor White.

6. For the dark blue under the wave crests, use layers of Copenhagen Blue, True Blue and Indigo Blue.

7. Use a colorless blender with lots of pressure over the colors you applied in the previous step.

Waiting in the Wings
Kelli Money Huff
Fluid acrylics and colored
pencil on Canson 100 paper
13" × 9" (33cm × 23cm)

11 Finish the Water With Colored Pencils

Beginning at the left, put a light layer of Beige pencil on the sandy area at the front edge of the water, getting lighter as you move toward the right.

Finish the waves, following the procedure shown at the top right of this page.

Where the water is a little greener, apply layers of Copenhagen, True Blue and Aquamarine. In the lighter areas of water, apply layers of Prismacolor White and Light Cerulean Blue.

To finish the upper part of the water, layer Copenhagen Blue, True Blue and Dark Indigo. Make these layers uneven, but do not try to depict each wave. After you get the colors and values the way you want them, use the colorless blender over all of the water to smooth it out.

Tips for this project: Test your ink colors on scrap paper first, since ink is permanent. Also, remember that with ink, you have only a short time to fix anything while it is wet.

Reference Photo

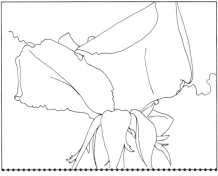

Line Drawing

1 Draw, Then Apply Ink Washes

Draw the rose lightly on the paper and clean up the lines with a kneaded eraser. Mix a very pale wash of Indigo Blue acrylic ink. Separately, mix a light- to medium-value wash of Lemon Yellow acrylic ink. Wet the back of the paper. On the front of the paper, wet everything except the flower. Wash Indigo Blue in the sky and the lower background evenly around the flower. Turn the paper around; while the blue wash is drying, you can work on the next part.

Wet the flower in the areas that have yellow, but do not let the clean water meet the blue area you already painted. Wash in the yellow mix where the flower is yellow, and bring the color down over the leaves and to the bottom of the paper. Let this dry.

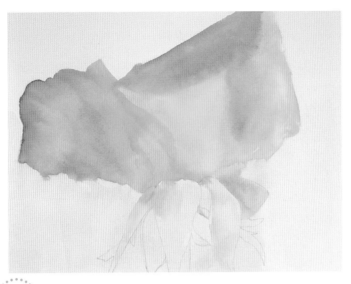

tip

Some parts of this piece will have light values and transparent passages. When transferring the drawing, draw lightly so your lines will not show through—or make sure the lines are neat and clean.

2 Add Pink Ink

Mix a medium-value wash of Rose acrylic ink. Wet the back of the paper with clear water. Wet the front of the paper only in the areas of pink in the flower and leaves underneath. Begin floating in the ink wash, first in the darkest pink areas and then in the lighter pink areas. Move the color around as needed. If it starts to dry, let it dry completely and then go in with more color. This helps to avoid hard edges, which you don't want on delicate flower petals.

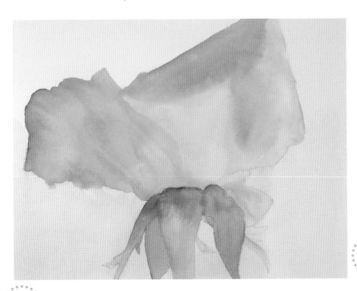

4 Wash In Sap Green Ink

Mix a light- to medium-value wash of Sap Green acrylic ink. Wet the back of the paper. On the front, wet the leaf area and the background up to where the dark part of the background meets the sky. Drop in the green and let it flow by moving and tilting your paper. Do not try to achieve an even wash, but if white areas remain, fill them in with a brush. Wet the area in the flower on the left side where there is a green vein and float in some pale green there. Let everything dry.

3 Add Indigo Ink

Mix a light wash of Indigo. Wet the leaves under the flower, then wash in the blue and let it float over the wet area. It is good to have places where the blue does not cover the yellow and green completely. Let it dry.

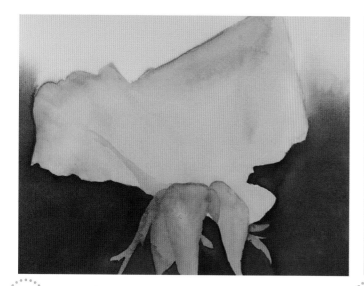

5 Strengthen Colors and Start the Background

If any of the colors aren't strong enough, first wet the area, then float in more color where needed. You can repeat as many times as needed as long as you let the layers dry in between. I added yellow and pink into the flower and more green in the vein of the rose.

Wet the back of the paper. Mix a strong value of Indigo acrylic ink. On the front, wet the dark background area, then paint in the Indigo. Let the green show through in some places. Let this dry, then assess the value. If you need another layer, let everything dry, then re-wet the paper and apply more color. Wet the leaves under the flower, then use a layer of Sap Green ink to darken the leaves where they are in shadow.

6 Add More Ink Color

Wet the dark pink areas where petals overlap, then add another layer of Rose acrylic ink. Don't forget the tiny rolled edge on the right side. Let this dry. Wet the dark areas in the leaves and the shadow areas of the flower, such as the bottom edge where the leaves meet the rose and where the large petal on the left overlaps the right petal, then drop in a light wash of Sap Green. If the green is too dark, immediately remove some color with your clean, damp brush before it dries.

7 Begin Adding Colored Pencil

Now it's time to use your colored pencils. Make sure the paper is completely dry first. Keep the pencils sharp unless otherwise stated, and build up color slowly with light layers.

Use Polychromos White to lighten areas of the flower, making your strokes follow the curves of the petals. Use the Prismacolor White over the Polychromos in areas needing a heavier coat of White. Edge the tiny leaves under the flower with Lemon Yellow colored pencil, then add Rose Madder or assorted pinks where there are touches of red and pink. Use Spring Green on top of the green ink on these tiny leaves and blend up into the larger leaves.

Rose
Kelli Money Huff
Acrylic ink and colored
pencil on Canson 100
paper
8¼" × 11" (21cm ×
28cm)

8 Finish With Colored Pencils

Darken the shadows under the larger leaves with layers of Olive Green and Dark Green. Put a layer of Dark Indigo in the very darkest areas. Where the leaves show a pink reflection underneath, use layers of Purple and Middle Purple Pink. Also apply Olive Green on the left side of the stem coming out of the leaves at the bottom. Use Spring Green on the right side to create a few tiny thorns coming off the stem. Where the larger leaves have light edges, put layers of Light Cobalt Turquoise, then Non-Photo Blue on these edges. Blend and soften the ink by running the pencils across the hard edges.

Add the pinks in the leaves with layers of Light Magenta and Fuchsia. Keep these layers thin and soft. Cover the blue areas of leaves with layers of Light Cobalt Turquoise and Non-Photo Blue. Blend these layers into the pink and right over the top lightly. Do at least one more layer of Non-Photo Blue over both larger leaves. In the darker parts of these leaves, use Dark Indigo and Ultramarine. The leaf on the right has light highlights; cover these with both of your White pencils. Blend the white right into the blues. Edge the leaf on the left with Dark Green on top of the Ultramarine and Dark Indigo.

Use Sunburst Yellow to intensify any yellow areas of the flower that need it. Now, finish the pink areas with a combination of all your pinks. Start with the darkest-value pinks, Magenta and Rose Madder, and put those in the brightest and darkest pink shapes. Use Pink and Hot Pink to smooth out and edge the lighter pink areas. Also use the middle- to dark-value pinks to clean up edges on the outside of the rose. If needed, use your whites in the lightest areas to contrast with the pinks and keep the luminosity of the petals.

watercolor with colored pencil

When I saw this little guy fearlessly hanging out with the gators and snakes at a wildlife preserve near my town, I had to take his picture and turn it into a painting.

materials

Watercolor Paints
Da Vinci: Arylide Yellow Deep, Cerulean Blue, Chinese White, Payne's Gray, Permanent Red, Prussian Blue
Sennelier: Arylide Yellow, Hooker's Green, Ultramarine Deep

Colored Pencils
Prismacolor: Apple Green, Black, Blue Slate, Burnt Ochre, Chartreuse, Cream, Dark Green, Indigo Blue, Kelp Green, Limepeel, Powder Blue, Sand, Sienna Brown, White
Polychromos: Light Cobalt Blue

Brushes
Assorted round watercolor brushes

Surface
Lanaquarelle hot-pressed watercolor paper, 300-lb. (640gsm), 9" × 12" (23cm × 30cm)

Other
Graphite pencil, small dish, plastic wrap (optional), tissue

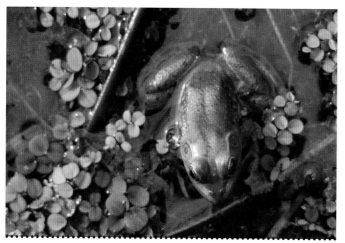

Reference Photo

Line Drawing

tip

When painting two leaves that share an edge, paint one and let it dry before painting the other one. Otherwise, the color will bleed from one to the other. Jump around, painting leaves in different areas, to give each one time to dry.

1 Start With the Greens in Watercolor

Lightly draw the subject on your paper. With a small round brush, put Hooker's Green, Arylide Yellow and Arylide Yellow Deep on your palette. Mix three separate puddles: Hooker's Green, green plus Arylide Yellow, and green plus Arylide Yellow Deep. Starting with dry paper, paint each small leaf with one of the three mixtures. This variety of greens will make the picture more interesting.

Some of the leaves have areas of light and dark. You can paint the whole leaf and then, with a clean damp brush, lift the color on the light side to lighten the value.

Paint the frog's back with a pale wash of Hooker's Green. Be sure to paint around the eyes; leave those white for now.

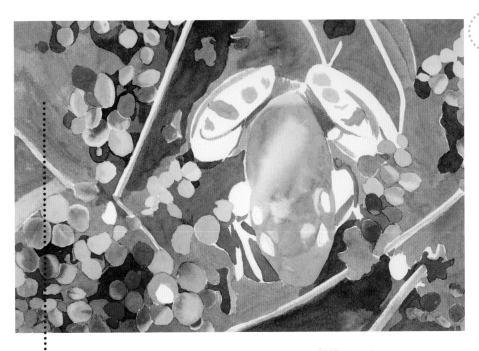

As you can see here, the hot-pressed paper really grabs the paint, resulting in many lines from all the stops and starts with the brush. That's OK; this is just the first layer.

2 Block In the Background

Mix equal amounts of Prussian Blue and Payne's Gray watercolor into a puddle of water in a small dish. Be sure to mix enough for the entire background so you don't run out. Then paint this wash into the dry background using a larger round brush with a good point (such a brush will let you paint large areas while also getting into the tight spaces between leaves). If you're mixing and painting with the same brush, be sure there are no clumps of paint hiding in the bristles.

Let this dry, then paint over the darker areas in the water with a second layer of paint to deepen the blue. If you have left-over paint from this step, cover it with plastic wrap; it might come in handy later if you decide the color still isn't deep enough.

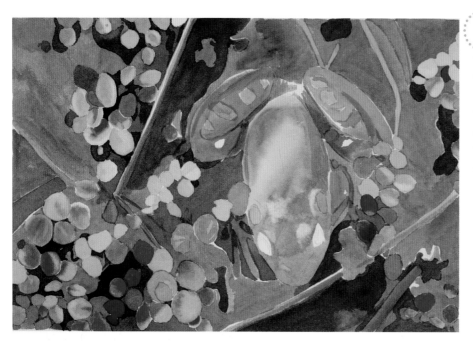

3 Add a Brown Mixture

On your palette, mix Hooker's Green watercolor with Permanent Red in equal amounts, plus a little water, for a fairly strong brown. Use this where shown to give the frog more color. Add a little more Permanent Red to the mixture, then paint the bits of plant stems in the water and add color to a few of the leaves.

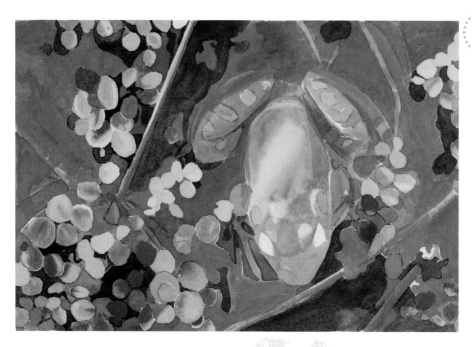

4 Paint Another Layer on the Water

Mix Ultramarine Deep with Chinese White and paint over all of the lighter values in the water. Also paint areas where the reflective water flows over plants and the frog's legs. Bring this blue-white mixture right over the brown on the legs. On some of the plants right under the surface there's just a hint of this color, so if your paint layer is too thick and covers it completely, dab lightly with a tissue to lift the paint and soften the effect. Let this layer dry completely. Congratulations—you've just saved yourself a boatload of time. If this were an all-colored-pencil painting, you'd still be on step 1!

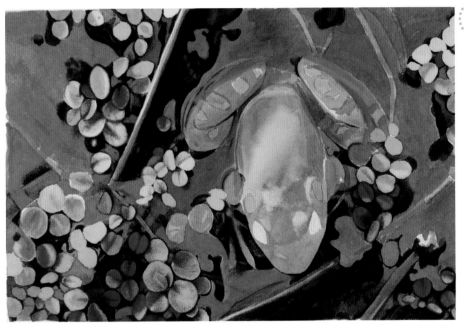

5 Begin Adding Colored Pencil

Layer Indigo Blue colored pencil in the dark areas of the water. Notice the variations of color and value within the darks; it's not just solid black. Use light to medium pressure and a sharp point on the pencil. Where the color is darkest, use a little more pressure.

Look closely at the dark areas: You'll see some greens and browns under the water's surface. Use Apple Green and Limepeel colored pencil to lightly layer some color into the Indigo. Lightly add Sienna Brown to the brown pieces of plant life in the water. In putting down the darks, you're also working around the small green leaves, so use Indigo colored pencil to clean up and define the leaf edges. Use Dark Green and Apple Green to start modeling lights and darks on the leaves.

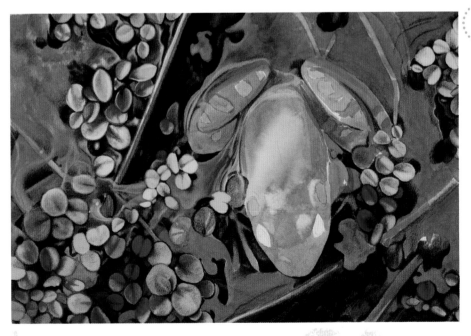

6 Add Colored Pencil to the Leaves and Water Reflections

Add variety and interest to some of the leaves with Limepeel, Chartreuse, Sand, Cream and White colored pencils. Look for light and dark values and highlight these. Use Sienna Brown, Kelp Green and Indigo Blue colored pencils to color the brown leaves. Refine the leaf edges with Apple Green and Dark Green.

For the reflections on the water, use Blue Slate colored pencil to blend between dark and light areas, then Powder Blue to bring up the lights. To really punch up the sparkles, add some accents with White. The water could still use a touch of a different blue, so add Light Cobalt Blue. This is a brighter blue and the Polychromos is a harder pencil, so the color will go down a little smoother. Be sure to use a sharp point and light pressure.

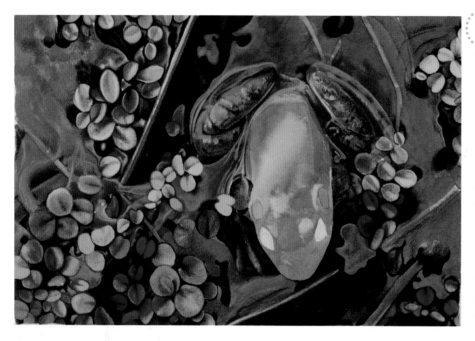

7 Detail the Legs With Colored Pencil

Starting with the back legs, layer Sienna Brown and Indigo Blue colored pencils for the dark values on the right side of the legs, and Cream, Powder Blue and White for the light side. In the green spots, add Apple Green and Dark Green. The brown of the legs has a few spots that are brighter in color. For those areas add some Burnt Ochre.

Notice the dark spots on the frog's legs that are just under the surface of the water. Put those in with a light layer of Indigo Blue followed by a light layer of Powder Blue. That light blue glaze over the dark really gives the impression of a watery film on the legs. Carry the Powder Blue glaze over the full length of the leg where it's submerged in the water.

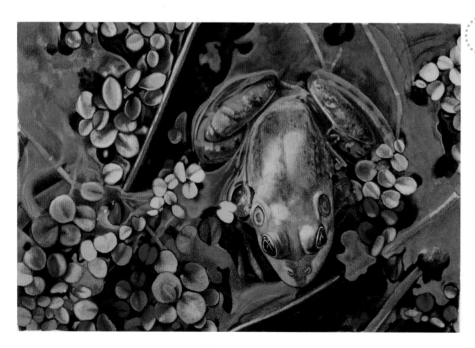

8 Detail the Back With Colored Pencil

Starting with Apple Green, block in the darker values from the frog's head to his back end. On the right side and on his head, use Dark Green to deepen the shadows. Define the eyes with Indigo Blue and Black. Be careful to color around the light rims around the eyelids—leave those white. Add a little Sand along the top of the eye where it meets the green. For the brown circles and spots on his back, use Burnt Ochre and Sienna Brown.

tip

The skin on the legs is textured, so apply colored pencil in these areas with a loose scumble stroke. Between that and the paper texture, you should be able to achieve a bumpy look without too much effort.

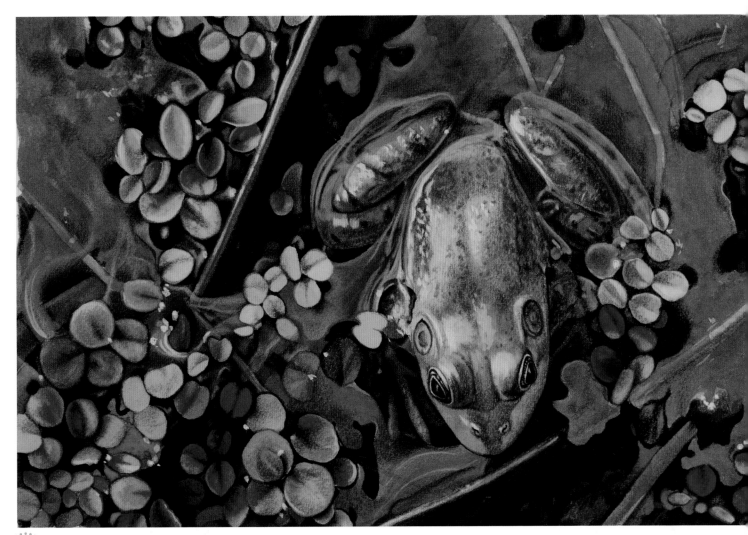

9 Add Highlights and Final Touches of Texture

With a small wet round brush, pick up some Chinese White watercolor paint and dab some white sparkles into the water. Do the same on the frog's back and legs. If, after the paint is dry, you find that the white looks dull and faded, try using some paint straight from the tube with very little water on the brush.

The frog still needs more texture on his back, so add some spots of color with Apple Green and Burnt Ochre colored pencil.

Payne's Prairie Floater
Carlynne Hershberger
Watercolor and colored pencil on hot-pressed watercolor paper
7" × 10½" (18cm × 27cm)

oil pastel with colored pencil

Oil pastel is beautifully suited to painting in a loose, impressionistic style. The sticks are like big, fat, mushy crayons, so it's difficult to do details with them.

Many of our students tell us, "I've been working in colored pencil for a while and I tend to be very tight with my work. What can I do to loosen up?" If you want to try something different that frees you from the minutiae of detail work, give this oil pastel project a try.

Reference Photo

materials

Colored Pencils
Prismacolor: Apple Green, Burnt Ochre, Cream, Dark Umber, Indigo Blue, Kelp Green, White, Yellow Ochre

Oil Pastels
Brown, Cream, Dark Purple, greens (a variety, light and dark), Indigo Blue, Yellow Ochre, Yellow-Orange, White

Surface
Canson Mi-Teintes paper, Red Earth (smooth side), 9" × 12" (23cm × 30cm)

Other
Graphite pencil, regular or crayon-shaped vinyl eraser, paper towels or tissues

Line Drawing

tip

For all of the oil pastel work in this piece, use a loose scumbling stroke. You want the oil pastel color to be "broken" so the color of the paper can peek through.

1 Do the Drawing, Then Begin Blocking In With Oil Pastels

With a graphite pencil, lightly sketch the tree and some basic shapes to indicate lights and darks of the ground and distant trees. The most important element is the placement of the main tree; the rest can be loose. Remember, oil pastel is thick, so you won't be worrying about details.

Layer Indigo Blue oil pastel over the dark background area. On top of that layer, use your darkest green oil pastel. Some of the Indigo Blue should show through the dark green layer. On the shadow side of the tree, apply a layer of Indigo oil pastel.

2 Continue With Oil Pastels

With the lighter green oil pastels, block in the rest of the trees in the landscape. Use Yellow Ochre, Cream and White oil pastels to block in the foreground and sky. Add some Yellow Ochre to the lighter areas of the foliage.

3 Smooth Out the Distant Darks, Then Add Color to the Trees

Smudge the dark areas in the distance with a vinyl eraser to smooth them out. Use a scumbling stroke with the eraser so that you don't completely cover up the paper tone. Wipe off the eraser, then smooth out the sky and foreground using the same technique.

With your lighter green oil pastels, begin to add color to the trees. Add yellow and white to bring out the sunlit leaves.

4 Continue Building Layers

Add layers of greens and yellow to the leaves with oil pastels. Use white to punch up the brightest areas of the leaves. Add more white to the sky area. On the shadow side of the tree trunks, add some purple.

tip

Keep in mind that oil pastel works differently than colored pencil. You can work light over dark and dark over light repeatedly without a problem. And most important: don't get bogged down in the details. Dab the color here and there with short choppy strokes. You're painting an impression of a landscape, not duplicating the photo.

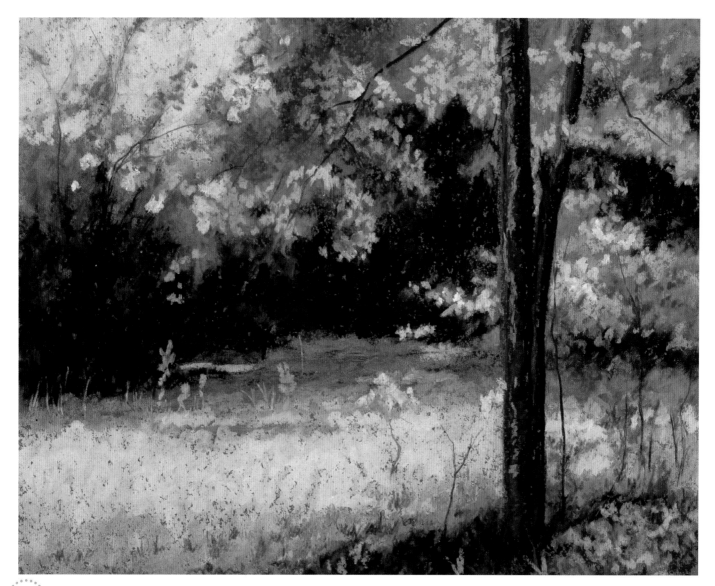

5 Finish With Oil Pastels, Then Colored Pencils

Add Brown oil pastel to the left sides of the tree trunks. On top of that, add cream oil pastel for highlights.

If you're a detail kind of person, we are now about to return you to your comfort zone. The edges of the trees should be cleaner, so use Dark Umber and Indigo Blue colored pencils to draw a nice clean line on the right side (shadow side) of the trunks. Keep a tissue in your other hand to wipe the oil pastel off the pencil point as it builds up.

Grab the rest of your colored pencil colors and put in branches, twigs and bits of grass. Use Dark Umber for the dark branch coming down from the top of the picture. For the distant branches that reach upward, use lighter greens or Yellow Ochre. In the foreground, draw dark twigs and weeds with Dark Umber, then light ones with Cream. Give some texture to the ground near the tree with Yellow Ochre. Push right on through the layers of Cream oil pastel with Yellow Ochre and Burnt Ochre colored pencils to add some darker areas.

Prairie Light
Carlynne Hershberger
Oil pastel and colored pencil on Canson Mi-Teintes (Red Earth)
8" × 10" (20cm × 25cm)

silver leaf with colored pencil

This piece, titled *One Missing,* is from a photo taken by my father-in-law, Floyd. He saw something on the street that looked like a manhole cover and thought it would make an interesting photo. I was intrigued by the textures and colors, especially in the circles that looked like purple glass. I did a little research and found that it was actually a skylight in the ground. These were used in the pre-gaslight era so underground workers could have some light. I love that there are still some of these around. It makes me wonder what the underground world looked like with the sun shining through those violet domes.

materials

Colored Pencils
Prismacolor: Beige, Beige Sienna, Black, Black Cherry, Black Grape, Burnt Ochre, Clay Rose, Cool Grey 10%, Dark Brown, Dark Umber, French Grey 30% and 70%, Goldenrod, Greyed Lavender, Henna, Lavender, Light Umber, Parma Violet, Peach Beige, Putty Beige, Rosy Beige, Sand, Sienna Brown, Silver, Slate Grey, Terra Cotta, White

Brushes
Assorted stiff bristle brushes such as Robert Simmons no. 2 flat and Loew-Cornell no. 0 brush for fabric dye (any stiff bristle brush in the appropriate size for the area will work)
Old brush to apply adhesive sizing
Soft goat hair brush

Surface
Crescent cold-pressed illustration board, no. 300 (lightweight) or no. 100 (heavyweight), 10" × 14" (25cm × 36cm)

Other
Odorless mineral spirits, paper towels, electric eraser, silver leaf; adhesive sizing or a leafing adhesive pen

Reference Photo

Line Drawing

1 Draw, Then Apply the First Layer of Colored Pencil

First, lightly draw the shapes on your paper. Next, you're going to put a layer of color over every area. Rough strokes are fine, because this layer will be dissolved wih mineral spirits in step 3. On the bricks on the right, go over the lines with Dark Umber, then layer with Henna and add some Sienna Brown on top. For the dark area to the left of the bricks, apply Burnt Umber. Color around the little stones; leave those white for now. Along the bottom, work some French Grey 30% in the areas between the stones. For the darkest areas inside the largest circles, put down Black Grape. For the moon-shaped shadows put down a heavy layer of Dark Umber. Use Sienna Brown to fill in the all the areas between the circles. On the one circle on the bottom right that doesn't have purple glass, use Goldenrod and Sienna Brown with Dark Umber on the right side between the stones.

2 Continue the Initial Colored Pencil Layers

Put a light layer of Parma Violet colored pencil on the centers of the circles. For the surrounding areas that are brown, layer Sienna Brown over all. On all the little pebbles across the bottom, put a layer of Goldenrod. Use French Grey 70% on the bolts. Even though there will be silver leaf on some of these areas, you still need the color underneath; it will show through the cracks in the metal. To define the rings around the purple circles, use Dark Umber.

3 Dissolve the Colored Pencil

Take a stiff bristle brush, dip it in odorless mineral spirits, dab it on a paper towel to get rid of the excess, and start dissolving the colored pencil (above, left). You'll have to use a bit of pressure to scrub the color and dissolve all of it. (Notice the dramatic color change.) On the purple circles (above, right), drag the dark color over to create a graduated tone from dark to light. Use the smallest brush to get down into the small spaces between pebbles and in the narrow rings around the purple. Use the mineral spirits to dissolve all the colored pencil on the piece.

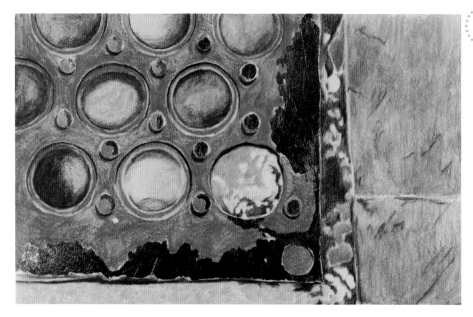

4 Apply Silver Leaf

Apply liquid adhesive sizing with either a brush or a leafing adhesive pen to areas where you want the silver leaf to stick: along the bottom and right sides of the plate. Also apply the adhesive to the appropriate areas of the bolts (on some, it's the right side; on others, it's the centers).

Let the adhesive sit until it feels tacky, at least 10 minutes. Then break off pieces of leaf slightly larger than the tacky area and gently place them on the surface. Tap the pieces down with your finger, then use a soft goat hair brush to brush away the excess. You might want to do this part over a trash can; the little bits of silver will fly everywhere.

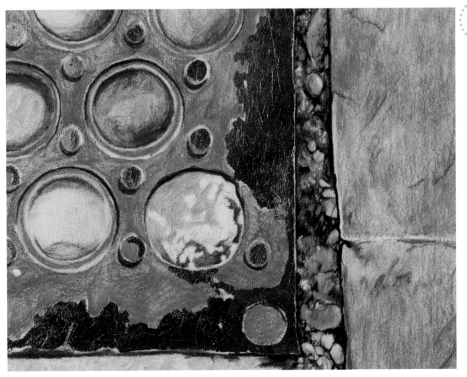

5 Add More Colored Pencil

Now you have a good base of color over all so it's time for more layers. Using Black Grape and Dark Umber, start defining edges to the left of the bricks. Add dark values around the pebbles. Don't worry about coloring around all the tiny light flecks. If you lose them you can always bring those back with an electric eraser. To add some interest to the area, grab a few other colors like Light Umber, Sienna Brown and Sand and use a scumbling stroke. Even with all these layers you can still add some light color on top of the dark for texture. Try adding Cool Grey 10% and French Grey 30%. Use Black along the edge of the brick and to bring up color in the stones, add Slate Grey to some and Burnt Ochre to others.

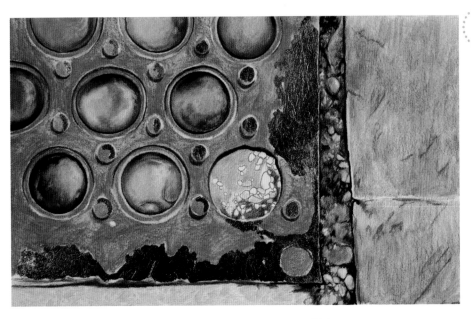

6 Apply and Dissolve More Colored Pencil

In the last step you worked dry. This time you'll be blending with odorless mineral spirits again. The surface of the purple glass is a little smoother than the other areas. Following the values of light and dark, layer Black Cherry, Black Grape, Henna, Rosy Beige and Lavender. Dissolve and blend this layer with the brush dipped in mineral spirits. To bring up the lighter areas, use Greyed Lavender and White. Let this layer dry. The largest circle on the bottom right—the "one missing"—has a lot of tiny bits of stone. Start by defining the outside ring with Black, Black Cherry and Henna. Then inside the ring, outline the largest shapes with Dark Umber.

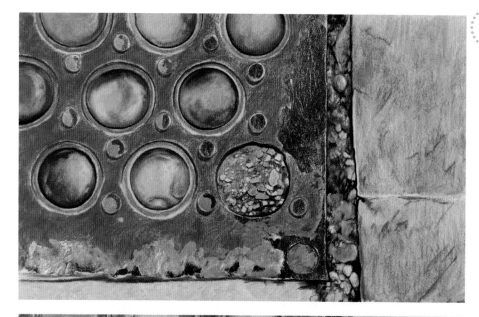

7 Add Texture and Distress the Metal

In the large circle, use Light Umber colored pencil to scumble some color and texture around the stones. Do another layer of Dark Umber on the right side and add some colors to the little stone shapes. Use a variety of colors such as Burnt Ochre, your French Greys, Slate Grey, Goldenrod, Putty Beige and Beige Sienna. For all the areas between the circles, loosely layer Dark Brown, then add random bits of Terra Cotta to spice up the color a bit and add interest. When you get close to the silver leaf, don't be afraid to take the pencil right over the edge of the metal and scrub. You want to distress the metal to give it an aged look.

Use mineral spirits to dissolve this layer of pencil, taking the brush over the metal too. Scrub along the edge to break up the leaf and make it look rough.

8 Deepen the Brown and Finish the Stones and Bricks

Continue layering Dark Brown around the circles and add a little Dark Umber to deepen the value. Really put some elbow grease into it along the silver edge; scrub hard to break up the silver and age it.

Use an electric eraser to pick out some small light stones here and there, then color each stone in with either Sand, Goldenrod or a French Grey for a variegated look. Add a dark edge along the bottom of the stones to represent shadows. Use a variety of grays and earth tones to fill in the stones along the bottom edge of the picture. Add a little dark shadow to the stones to give them dimension.

Finish the bricks with layers of Rosy Beige, Clay Rose and a touch of Greyed Lavender and Beige. Add some Henna and Sienna Brown for the darks. Use Dark Umber to add some creases and marks for texture.

9 Finish

Finish working the stones on the bottom. Clean up edges on the circles by using any of the dark-value pencils such as Dark Umber, Black Grape or Black Cherry. Deepen the shadows with Black. Also use Black to create the shadows beneath the bolts. Darken the left sides of the bolts with French Grey 70%. Dissolve the gray on the bolts with odorless mineral spirits and once again scrub along the edge of the silver to distress. Add some Silver Prismacolor pencil to make a nice transition from the shine of the metallic leaf into the duller areas on the left. Also use this to blend these two areas together on the bolts and on the larger silver leaf sections. When covering a larger area, try rubbing the side of the Silver pencil lead on the surface to enhance the texture.

One Missing
Carlynne Hershberger
Colored pencil and silver leaf on illustration board
8¾" × 12½" (22cm × 32cm)

monotype

Monotypes are perfect for experimentation. Try using lots of paint or ink; try using just a little paint or ink with more pencil; or add a third medium. Every project will be different.

Reference Photo

materials

Colored Pencils
Prismacolor: Beige, Black Cherry, Black Grape, Dark Brown, Dark Umber, Henna, Sienna, Yellowed Orange

Water-Soluble Block Printing Ink
Blue, Brown, Dark Yellow, Orange, Red, Turquoise, White

Brushes
Assorted synthetic rounds and flats

Surface
Stonehenge paper, any shade of white; 12" x 9" (30cm x 23cm)

Other
Acrylic printing plate, flat palette or extra piece of acrylic sheeting, small rubber brayer, baren or wooden spoon, artist's white tape, paper towels

Line Drawing
Monotype always prints in reverse, so to get the results shown, use this "backwards" drawing as your pattern. Enlarge this on a photocopier first by 200%, then by 175%, then put it under your acrylic sheet printing plate.

1 Work the Sky

Tape your paper and plate in the manner described on pages 71–72. Mix some Turquoise, Blue and White printmaking ink. When you are happy with the color, roll it on the entire sky area of your plate with the brayer. Print the sky on your paper and clean the plate. Remember, this is monotype; there will be breaks in the ink and paper peeking through. This is what makes monotype so unpredictable and wonderful. Let the ink dry.

2 Add the Trail

Create a pale beige mix for the trail using White ink with a dab of Brown. Paint this onto the plate over the trail in the drawing. Print, then clean the plate with damp paper towels. Let the paper dry. As the ink gets thicker on the paper, it will take longer to dry. Humidity will make it tacky even when it is dry.

3 Add Grasses and Trees

For the grasses and trees, combine Dark Yellow ink with a touch of Orange. Do not worry about getting it evenly mixed. Add some White and partially mix it into the other colors. Let it be streaked and uneven. Use a medium flat brush to paint the grass on the plate in the direction it grows. Use a round brush to dab in the color of the trees on the plate. Print and clean the plate. Wait for the paper to dry.

4 Punch Up the Orange

Add more Orange to the mix from step 3 and dab it onto the plate in areas where more color is needed. Print, then clean the plate.

5 Punch It Again

At this point, I decided I still didn't have the coverage I wanted in the orange and gold areas. I wanted the grass to look lush and almost fluffy and the trees to be full with just a little sky showing through. So I did another layer of orange. When the paper is dry, you can print the same color and areas as many times as needed to get the right color and value. It's a good idea to wait until the ink is dry between layers because reprinting on wet ink will usually pull color off.

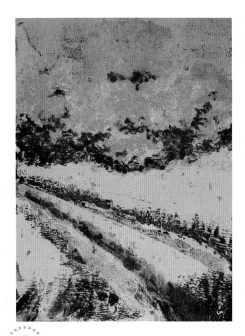

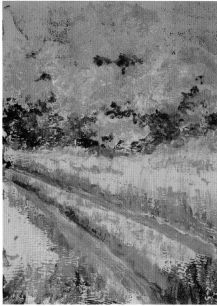

7 Soften Some Edges

Mix Red ink with Brown and some White and paint this onto the plate around the browns from step 6 to blend them into surrounding areas. Print, then use a flat brush directly on the paper to add or move ink as desired. Move the brush in the direction the grass lies.

6 Add Brown to the Grass and Shadows

Paint Brown ink onto the plate in the darker areas of grass and the shadows under the trees. Print, let dry, then assess the color and values. If needed, you can print again now, or wait until you add more colors.

8 Finish the Trees

To finish printing the trees, mix three ink puddles: Orange; Orange plus Brown; and Dark Yellow. Place these mixes on your palette separately and paint them into tree areas on the plate as shown here, using a dabbing motion with a round brush. Print, then paint more of these colors on the paper directly with the same dabbing motion of your brush. Let dry. When you are happy with the trees, use a brush directly on the paper to put some Dark Yellow on highlight areas. Clean your plate and let everything dry.

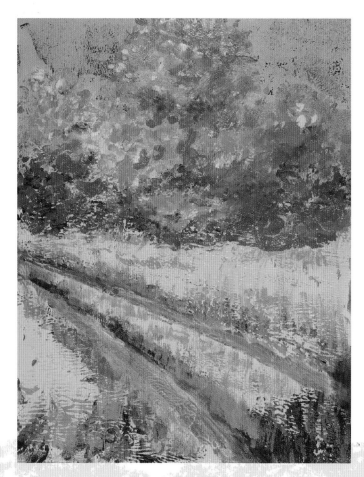

9 Finish With Colored Pencils

The ink must be completely dry before you begin using colored pencil on it. In this step, make your strokes loose in keeping with the nature of monotype.

Use Dark Brown colored pencil at the edges of the road. Add Sienna to the Dark Brown in the darker areas in the grass. Keep the pencil sharp for these areas, but do not try to describe every blade of grass. For the red weeds in the grass, use Henna. Add Dark Umber to further darken values where needed. In some of the dark areas, you can try using your pencil on its side and take advantage of the textures of the ink.

Use a Beige pencil for the tracks, then Yellowed Orange over the Beige layer. For the very darkest darks, use Black Cherry in the trees and Black Grape in the shadows under the trees. These two colors can also be used to touch up darks in other areas here and there, especially along the road edge. Look at your piece and decide if it is done or if you want to do more. Monotypes involve a lot of surprises; try to stay loose and go with it.

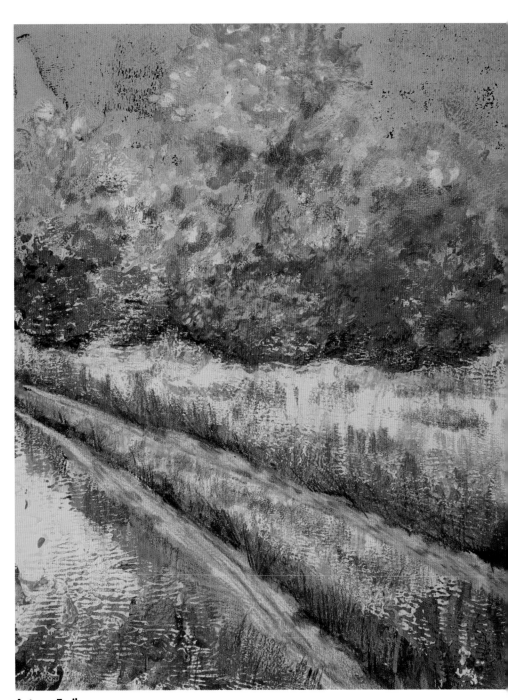

Autumn Trail
Kelli Money Huff
Colored pencil and water-soluble block printing ink on Stonehenge paper
10" × 8" (25cm × 20cm)

conclusion

We all want to make the best art we are capable of. To be the best you can be, learn as much as you can. We have no patience for nonartists who believe that art comes from talent rather than hard work. You, as an artist, know that with all the talent in the world, nothing happens without time, energy and work.

We are teachers as well as artists, and we love to pass on what we have learned in our many years of experimenting. If it were possible, we would have included everything you ever needed or wanted to know about art in these pages. However, that is beyond the scope of this or any book, even the ones whose titles begin with *The Complete Book of* It is up to you to educate yourself, and there are many ways to do it.

Study the elements and principles of design, and learn how they apply to composition. Whether you take a class or read a book, design is important and can be learned. Understanding how to combine the elements in your composition will dramatically improve your work.

We also get frustrated with the many people who say, "I paint, but I can't draw." We maintain that if you can't draw, you really can't paint. Never, ever underestimate the importance of drawing skills in all forms of the visual arts. Even if you use a projector or trace your drawing by other means, you need to be able to draw or it will show in your artwork. Get a sketchbook and use it as often as possible. To make it easy, just carry a pencil, an eraser and small spiral-bound sketchbook no larger than 9" × 12" (23cm × 30cm). You don't have to plan a drawing; just draw what you see in front of you. It could be the window in your living room, the desk in the doctor's office, or a tree you see in the schoolyard while waiting for your child. Date each sketch you do, and you will have a visual record of your progress and many ideas for paintings.

All the arts are related; there is composition in music and dance as well as in painting and sculpture. Take the opportunity to see art of all kinds whenever you can. Go to galleries and museums, symphonies and stage plays. Listen to music when you paint, and think about what types of music you prefer. Read art books and magazines. Expose yourself to as much art as you can, even art you don't like. You may change your mind, or you may learn something you didn't know before that will improve your work. If you immerse yourself in the arts, your painting and drawing will greatly benefit.

And don't forget to enjoy the process.

Shadows on the French Quarter
Kelli Money Huff
Colored pencil
14" × 8¼" (36cm × 21cm)

index

Are you itching to expand your creativity into new mediums? *Paint* is your essential guide to techniques for all the major painting mediums (acrylic, colored pencil, oil, pastel and watercolor). This informative and inspiring book covers materials, color, value, composition, and step-by-step painting techniques and demonstrations, all clearly and beautifully illustrated. It's everything you need to begin, develop and perfect your craft.

ISBN-13: 978-1-58180-870-4
ISBN-10: 1-58180-870-4
Paperback, 224 pages, #Z0228

A must-have for your tool kit, *The Watercolor Bible* gives you inspiring artwork, friendly, comprehensive instruction and indispensable advice for nearly every aspect of watercolor painting. It's small enough to take anywhere, and wire-bound so you can flip it open and reference it while you paint!

ISBN-13: 978-1-58180-648-9
ISBN-10: 1-58180-648-5
Hardcover with concealed wire-o binding, 304 pages, #33237

Colored Pencil Solution Book answers the most frequently asked questions about colored pencils, covering topics from setup, technique and application to color, texture and light. This easy-to-use reference contains more than 70 tips and techniques for winning results.

ISBN-13: 978-1-58180-919-0
ISBN-10: 1-58180-919-0
Paperback, 128 pages, #Z0412

The Drawing Bible is the definitive drawing resource for all artists! Craig Nelson clearly explains basic drawing principles and shows you how to use a wide variety of drawing mediums, both black-and-white and color. Demonstrations and beautiful finished art throughout will instruct and inspire you, and the book's chunky size and spiral binding make it convenient to use and easy to carry anywhere.

ISBN-13: 978-1-58180-620-5
ISBN-10: 1-58180-620-5
Hardcover with concealed wire-o binding, 304 pages, #33191

These books and other fine North Light titles are available at your local fine art retailer or bookstore or from online suppliers.